MW00603823

Images of Modern America

SPOKANE'S EXPO '74

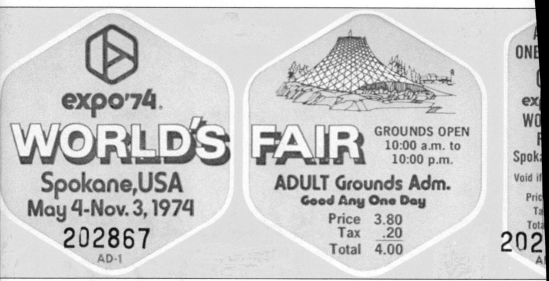

When compared to today's theme park prices, Expo '74 was quite a bargain. Tickets were priced at $4.00 for adults, $3.25 for youths (ages 12 to 16), and $2.00 for children (6 through 11); children under six were free. Season passes were an even better deal; an adult pass was only $45. (Author's collection.)

FRONT COVER: Great Northern Clock Tower and United States pavilion (Author's collection)

UPPER BACK COVER: Howard Street Mid-Channel Bridge and United States pavilion (Author's collection)

LOWER BACK COVER (from left to right): British Columbia pavilion (Author's collection), International Amphitheater (Author's collection), Republic of China pavilion (Author's collection)

Images of Modern America

SPOKANE'S EXPO '74

Bill Cotter

ARCADIA
PUBLISHING

Published by Arcadia Publishing
Charleston, South Carolina

Library of Congress Control Number: 2016950318

For all general information, please contact Arcadia Publishing:
Telephone 843-853-2070
Fax 843-853-0044
E-mail sales@arcadiapublishing.com
For customer service and orders:
Toll-Free 1-888-313-2665

Visit us on the Internet at www.arcadiapublishing.com

To Carol. Thanks for your ongoing support, help, and encouragement.

CONTENTS

ACKNOWLEDGMENTS

Each time I write a book, it seems I go through the same phases. At first there is the fear I will not have enough photographs, which is then followed by worries about too many and the need to cut some out. While I have thousands of images in my collection, there always seem to be one subject or two that have somehow eluded me. In some other cases, I may have a photograph of a specific subject, but it was shot in poor light, or there is some distracting element or other flaw. It has always been a welcome pleasure to get help from my fellow world's fair enthusiasts, and this book is no exception. My thanks go to Ellen McFadden and Robin Adams for the use of their photographs. Unless otherwise noted, all images are courtesy of the author's personal collection.

Thanks also go to the members of www.worldsfaircommunity.org, particularly Wayne Bretl, for their help in tracking down some of the facts and figures from Expo '74 and for their suggestions and corrections along the way.

I also appreciate the assistance and helpful suggestions of Kevin Twohig, who was instrumental in the success of the Expo '74 Entertainment Division.

I have to save the biggest thank-you for my wife, Carol. Besides being more than understanding about my collecting all of these pictures and other souvenirs from world's fairs, she is always there for me as I put a book together. From helping me get past a dose of writer's block to proofreading and editing the text, and for patiently listening to yet another excuse as to why my office is awash in paper yet again, she has been a more than helpful partner.

INTRODUCTION

It is difficult to properly describe a world's fair to someone who has not experienced one. Sadly, an ever-increasing number of people fall into that category, as the United States has not hosted a fair since 1984 and the last ones held were not well attended. In a way, they are like the mythical Scottish town of Brigadoon, which is said to appear magically every 100 years, then vanishes after only one day. Expo '74 lasted six months, not just a day, but the story of its creation is, indeed, somewhat magical.

World's fairs, or expos, have been held for a wide variety of reasons. The vast majority have been created when business and civic leaders joined forces to draw attention to the host city in the hope of attracting new businesses and investments. Some fairs were launched on a more nationalistic basis, but generally for the same reason, the hope of increased economic benefits. Those responsible for Spokane's Expo '74 undoubtedly hoped their fair would bring new attention to their city, but the real reason for holding it was rather unique. They wanted a new city park.

Spokane's location is due in large part to the falls on the Spokane River at the heart of the city. The falls provided an important source of power for the growing city, and over the years, the area became heavily industrialized. The river area became an important railroad hub after one of the river channels was filled in to make the former Havermale Island into little more than a peninsula to provide more room for the trains. More and more industries located in the area, including a water pumping station, hydroelectric facility, laundries, and a host of other companies wanting to take advantage of the river.

By the 1960s, the area was a blighted and contaminated mess. Decades of uncontrolled use of the river had left it highly polluted. Rail traffic had slumped precipitously with the arrival of cheap air travel and the interstate highway system, leaving the heart of Spokane a little-used and forlorn area that was in dire need of help.

There had long been an interest in developing a public park in the area, but funding always proved to be an issue. The group Spokane Unlimited was formed to explore ways to revitalize the area, including the usual thoughts of bond issues or new taxes, but what ultimately arose was the extremely unlikely decision in 1970 to hold a world's fair.

In 1962, Seattle had hosted a very successful fair that helped create a major new park. That experience was not lost on the Spokane team, which began developing plans for its own international exhibition. Bringing these initial ideas to fruition proved to be quite a task, one that many critics boldly claimed could not be done, but the organizers plowed their way through each of the obstacles they encountered. The team was led by King Cole, the dynamic president of Expo '74, who pushed through countless obstacles to bring the fair to fruition. Cole had been hired by a group of Spokane business leaders in 1963 to help revitalize the city, and with Expo '74, he more than succeeded.

One of the biggest hurdles Cole and his team faced was proving to the world, and certainly to would-be investors and participants, that Spokane had the wherewithal to pull off such a large event. Spokane was the smallest city to ever host a world's fair and, on the surface, it was an

unlikely place to hold one. The city and surrounding area were not large enough to generate the number of visitors the fair would need to turn a profit, and it was certainly not a major tourist attraction that could easily count on large numbers of outside guests.

The solution to this was to hold a fair that was large enough to get the job done, but to not aim too high and try to build anything on the scale of other recent fairs, such as the mega ones held in New York and Montréal. For comparison, Expo '74 cost an estimated $30 million, and Montréal's Expo '67 was estimated at more than 10 times that amount.

With plans and a budget in hand, the fair's leaders approached the Bureau of International Expositions (BIE) for its endorsement and backing. The BIE was founded in 1928 to regulate world's fairs, and this would mark the first fair held in the United States since it joined the BIE in 1968. The BIE has a set of rigid requirements, including the length of the event, rental rates for international exhibitors, and, perhaps most importantly for Spokane, a mandate that each fair cannot compete with another one. Fortunately, no one else was vying to hold another fair in the contemplated window, and on November 24, 1971, the BIE blessed the Spokane plans.

There was one other major obstacle that needed to be overcome before the fair could actually take place. The city did not own the site it had selected and would need to somehow get control of it from the three railroads that owned 17 acres in the heart of the project, as well as deal with the many small businesses along the river. The critics again proclaimed that the project was doomed, for there was certainly no money available to buy out the Burlington Northern, Union Pacific, and Milwaukee Road Railroads. Much to the naysayers' surprise, Cole convinced the companies to donate the land, and on June 1, 1972, the city received ownership of the site. With that, work on the fair went into high gear.

Originally, the intent had been to hold the fair in 1973 to commemorate the 100th anniversary of the city's founding, but the delays in obtaining the needed approvals made it apparent that was too ambitious a plan, and the date was pushed back a year. Now known as Expo '74, the fair used the theme "Celebrating Tomorrow's Fresh New Environment" to tie into an overall focus on the need to improve the environment, which partnered nicely with Spokane's own plans for the river area. The organizers also announced that the fair would be the first event to celebrate the upcoming United States bicentennial.

One last hurdle arose in 1973 when the United States found itself enmeshed in the oil shortage caused by OPEC cutbacks. There were serious concerns about visitors being able to get to Spokane, but fortunately fuel supplies loosened up in time for the event. The crisis may have actually helped Expo '74, for exhibitors such as Ford and General Motors used it to heavily promote their newfound focus on fuel economy.

Expo '74 ran from May 4 to November 3, 1974. When it was over, a recorded 5,249,130 visitors had passed through the gates. The fair was critically well received, generated a profit, and, most importantly, served to launch the creation of what is today known as Riverfront Park. Cole and other members of the Expo '74 management team went on to serve in similar roles at the 1982 and 1984 world's fairs, but they left behind a lasting legacy from their years in Spokane. Visitors to the area today will scarcely believe how much the area has changed from the polluted wasteland that existed before Expo '74.

One

BRINGING EXPO '74 TO LIFE

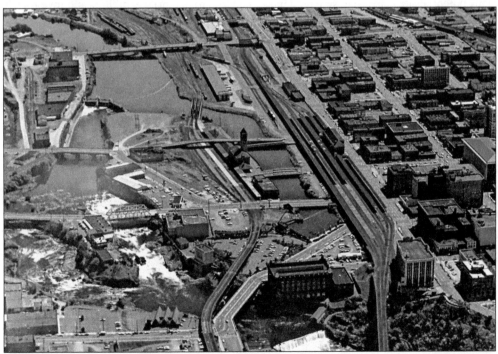

The site chosen for Expo '74 has the dubious distinction of being perhaps the most unlikely spot ever picked to house a world's fair. Located in the middle of a hydroelectric plant, Havermale Island and the nearby mudflats were home to an abandoned railroad station, little-used freight tracks, rundown factories and storage yards, and tons of polluted soil, all of which needed to be removed before construction could begin on the fair's pavilions.

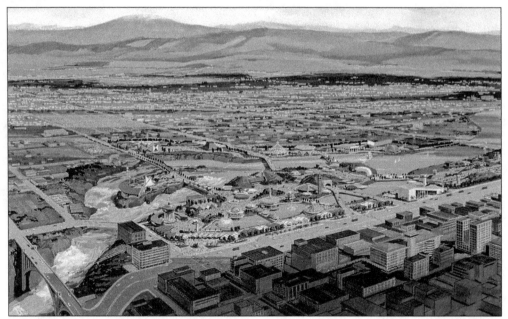

Expo '74 was not certified as an official world's fair until late 1971, giving the organizers less than three years to secure all of the acreage, design the site, and build the pavilions. This is one of many potential site plans that were used in sales pitches to potential exhibitors and investors. It appears the Washington State pavilion was the only pictured element that was actually built.

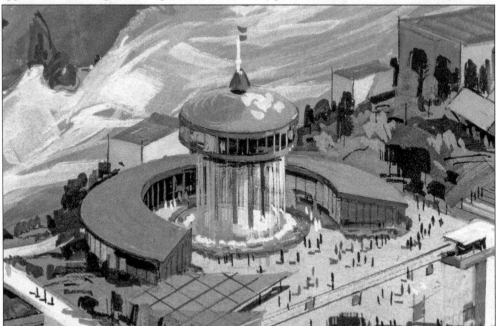

Most world's fairs have a theme structure, usually a tower soaring high above the rest of the pavilions. Expo press releases promised "a theme structure that will uniquely depict the Exposition theme." Several concepts were released; the one that got closest to being built was a rotating restaurant that would have seemingly been suspended atop a waterfall cascading down from the building. The lack of a sponsor or alternate funding led to the project being canceled.

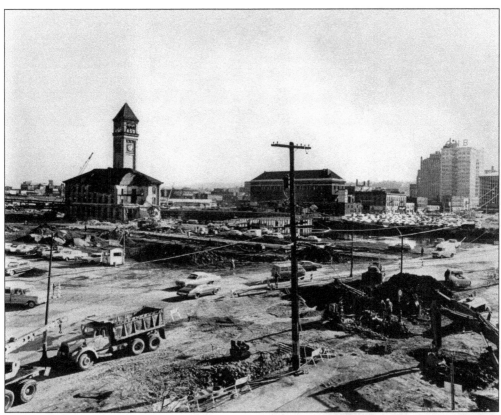

When all of the approvals were finally received, work began on the massive chore of clearing the existing structures on the site, including moving the operations of four railroads. While most of the old Great Northern Railway train station was razed, the clock tower was left as a permanent addition to the post-Expo park. Large numbers at the top were changed each day to show how many days were left until opening day; at 450 days, this would be February 8, 1973.

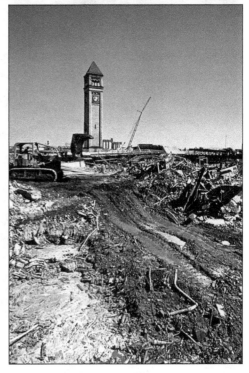

Although the Great Northern Clock Tower was generally in good shape, there was one major problem in getting it ready for the fair. On April 25, 1973, thieves stole a number of brass parts from the mechanism, rendering the clock inoperative. Happily, a group of city workers and students from Spokane Community College joined together to hand forge new parts based on historical photographs of the workings, returning the clock to service again just in time for the fair.

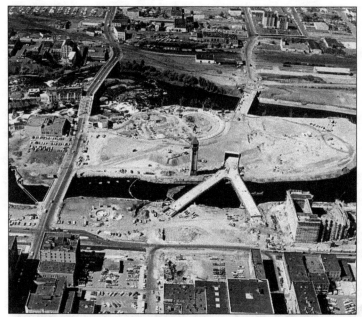

Tearing down the old buildings and railroad trestles was a massive job. The environmentally friendly themed fair found itself with some unwelcome publicity when challenges arose to the initial plans to dispose of the contaminated soil and building materials. Threatened delays to the schedule were averted when more suitable plans were developed. By mid-1973, the site was finally cleared and construction of the fair buildings had begun.

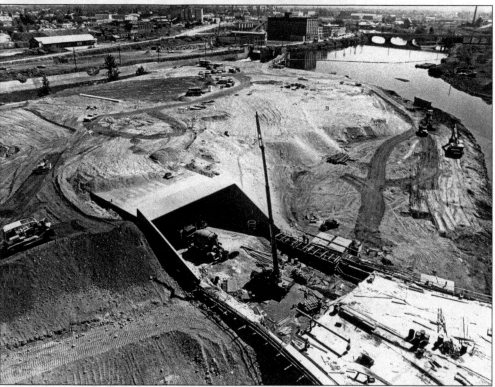

The previously flat contours of Havermale Island may have been ideal when it was occupied by the railroads but a great deal of work was required to reshape it for Expo. Hills were constructed using imported fill dirt, both to make the site more interesting and to provide a tunnel across the site for regular Spokane traffic. Work is seen here on June 11, 1973, on the vehicle bypass and the future site of the Soviet Union pavilion.

A slightly wider view taken the same day shows the beginnings of the United States pavilion to the left of the clock tower. The ramp to the right of the tower is now North Stevens Street. In the foreground is the Coeur D'Alene Hotel, which opened in 1909 and is now known as the Milner Building. The cleared plot next to it is where Union Station once stood.

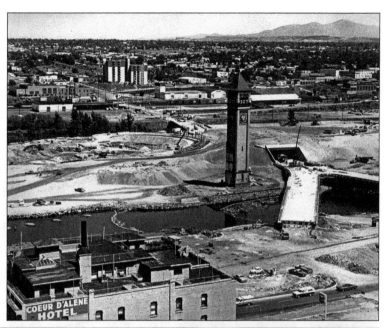

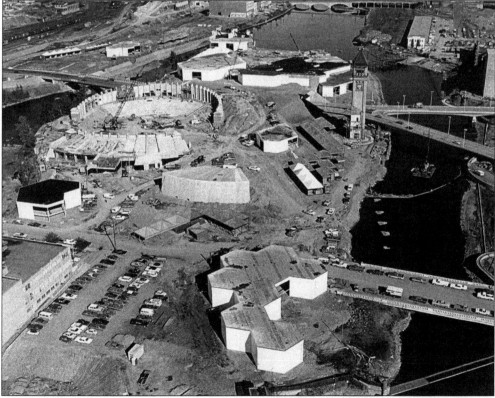

By September 26, 1973, the site looked quite different. Many of the pavilions were well under way, but there was still an enormous amount of work to get Expo ready for its grand debut on May 4, 1974. All of the walkways were still to come, as was the landscaping that was essential to make the site match Expo's environmentally friendly theme.

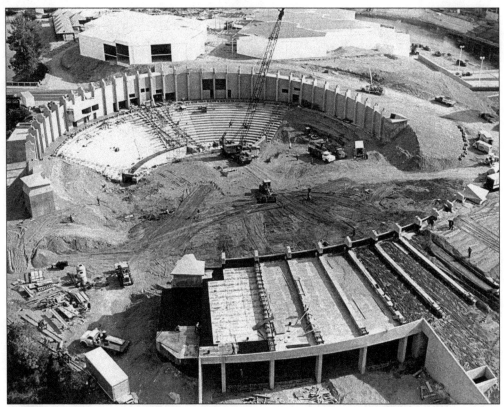

One of the amazing things about world's fairs is the tremendous effort that goes into an event that only lasts six months. The United States pavilion, seen here in 1973, would only be used for the 184 days of Expo '74, with no clear plans for later reuse. The cost to build the pavilion was $11.5 million, which translates to an impressive $62,500 per day; adjusted for inflation, it would be $340,000 a day in 2016—plus the cost to staff and operate it.

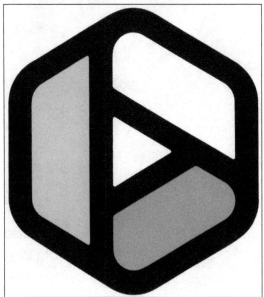

The Expo '74 symbol is described in an official press release as "a flat plane of the Mobius Strip, a three dimensional form which has only one side and therefore no definable beginning and no end. The symbol expresses the continuity of life—man's inescapable relationship with all things in his immediate environment and in his total universe. The three colors represent: the cleanliness of clean air (white), the purity of clean water (blue) and the unspoiled beauty of growing plants and trees (green)."

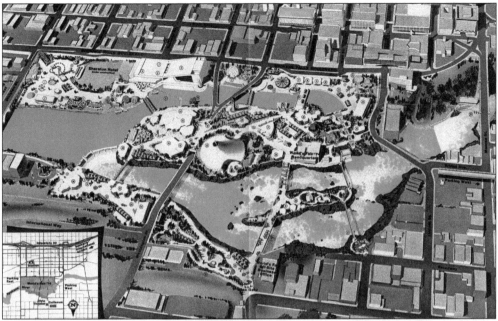

During the construction phase, there were constant changes to the fair's overall design, with pavilions being added, moved, or canceled as negotiations with potential exhibitors went on. Finally things settled down enough to produce an official map and visitor guide. Spokane area residents were undoubtedly a bit confused when they tried to orient themselves—for some reason, the map was drawn with north at the bottom, unlike most other maps. Copies of the final site plan were widely distributed to press outlets and used in advertising, helping to draw attention to the event.

Key to Map Numbers

Concessions and Rides

1 Great Northwest Midway
2 Riverview Restaurant
3 Taiwan Restaurant
 Fresh Fruit Stand
 Fish Fly Shop
 Expo Souvenirs
 Strollers
 Balloon Ride
 River Boat Ride
9 A & W Sky Float
13 International Bazaar
 Photo Finishing
 India Kashmir Shop
 Thailand Imports
 United Nations Shop
 Mexican Boutique
 Philippines Imports
 Ice Cream
 Expo Souvenirs
 Taiwan Imports
 African Imports
 American Indian Gifts
 Japanese Imports
 Clock Tower Restaurant
 Canadian Mounted Police Records
14 Hamburgers, Authentic Foods of India,
 Souvenirs
15 Bavarian Gardens
16 French Food
21 Souvenirs
 Indian Imports
 Monogrammed T-Shirts
 Jewelry
22 Strawberry Shortcake, Expo Souvenirs,
 Ice Cream,
 Pizza, Hamburgers, Korean Imports
24 Ride Over The Falls
28 A & W Root Beer
34 Food Fair
 Chicken
 Indian Food
 Philippine Food
 Canadian Food
 Health Food
 Belgian Waffles
 Mexican Food
 Japanese Food
 Chinese Food
 Hamburgers and Hot Dogs
 Pizza Parlor
 Blended Fruit Juices
40 Glass Blowing and Cutting
 Coin Jewelry
 American Indian Handicrafts
 Far East Carver
 Leather Shop
 Pearl and Oyster Shop
43 Soviet Restaurant
47 Buffet Restaurant
 Sandwich Shop
 Ice Cream Shop
 Candy Shop
 Expo Souvenirs
51 Hamburgers and Fish & Chips
 United Nations Shop
 Expo Souvenirs
52 Thailand Imports
 Philippine Imports
 Greek Imports
 Holland Imports
 Expo Souvenirs
 Candy and Ice Cream
 Japanese Restaurant
 Jewelry Shop
 Pizza Parlor
55 Photo Finishing
58 Indian Imports
 Expo Souvenirs
 Strollers
 Ice Cream, Hamburgers
 Water Falls Restaurant
65 Gallery Barbizon

Services

4 Restrooms - 7 locations
31 Travel Terrace
 Hughes Airwest
 Pacific Northwest Travel Association
 Spokane River Expeditions
 Currency Exchange
 U.S. Postal Service
 American Association of
 Retired Persons
33 Child Care Center
 Lost and Found
 First Aid
64 Safeco Information Center - 3 locations

Pavilions and Exhibits

5 The Art Gallery: Our Land, Our Sky, Our Water
6 KinoAutomat-Czechoslovakia's
 Decision Cinema
7 Washington State Exhibit
8 Washington State Opera House
10 Northwest Orient Airlines Exhibit
11 Ford Pavilion
12 The Great Northern Clock Tower
17 Sermons from Science Pavilion
18 Montana and California Pavilion
19 Idaho and Oregon Pavilion
20 Vanishing Animal Pavilion
23 General Motors Pavilion
25 Energy Pavilion
26 Afro-American Pavilion
27 Theme Promenade
29 Japan Pavilion
30 American Forest Pavilion
32 Kodak Pavilion
35 Book of Mormon Pavilion
36 Iran Pavilion
37 Republic of China Pavilion
38 Plaza Mexicana
39 United States of America Pavilion
41 Department of Ecology Pavilion
42 USSR Pavilion
44 Federal Republic of Germany,
 Philippines,
 NASA: Rediscovering the Earth
 Department of Interior Exhibit,
 Environmental Symposia:
 Learning to Live on a Small Planet
45 Wash. State Dept. of Ecology
46 Expo '74 Club (private)
48 International Amphitheatre
49 Australia Pavilion
50 Bell System Pavilion
53 Republic of Korea Pavilion
54 Joy of Living Pavilion
 United Airlines
 Whirlpool Corporation
 Union Pacific
 Amtrak
 Bureau of Reclamation
 Fiberform
 Washington Public Ports Association
 Upper Columbia Academy
 Schweitzer Basin
 RAHCO
 Keytronics
 Environaire
56 Folklife Festival
57 Union Pacific Steam Engine Exhibit
59 Point of Inspiration
60 Canada Island
61 British Columbia Pavilion
62 Alberta Amphitheatre
66 Native America's Earth

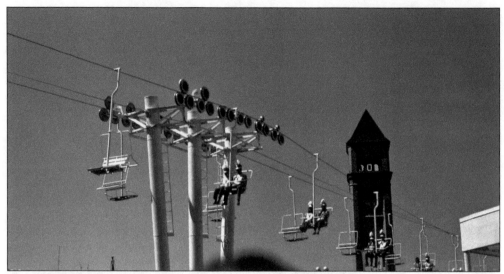

Finally, the numbers on the clock tower reached the end of their long countdown. All of the work paid off when Expo '74 opened on May 4, 1974. A crowd of 85,000 visitors braved unseasonably low temperatures as a long list of politicians and entertainers extolled the virtues of Spokane, the fair, and the need to improve the environment. Here, some band members enjoy a trip on the A&W Sky Float aerial tram ride between practices on the day before the fair officially opened.

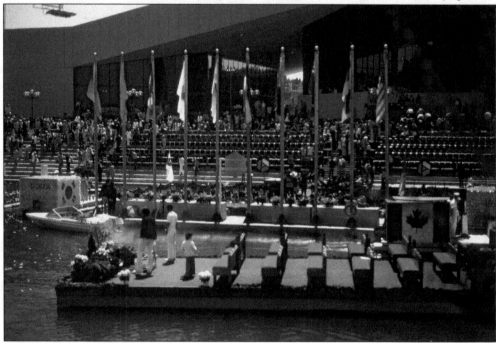

The opening ceremonies were held on a stage located in the Spokane River in front of the Washington State pavilion. Because of the large number of dignitaries and guests involved, additional seating on temporary barges was added for the occasion. Behind the barge units of the Floats of Nations, smaller barges decorated with the national insignias of the exhibiting countries can be seen. The ceremonies included releasing 1,974 trout into the Spokane River to celebrate the cleanup of the area for the fair.

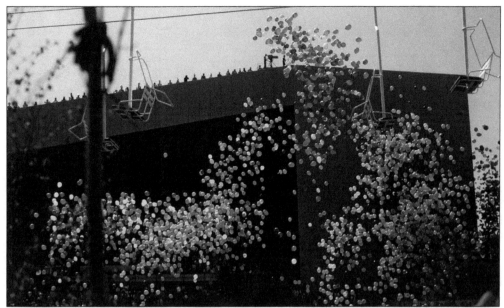

After Pres. Richard M. Nixon proclaimed that "it is my high honor and privilege to declare Expo '74 officially open to all of the citizens of the world," 50,000 helium-filled balloons were released and the pavilions opened their doors. It is interesting to see how views on ecology have continued to evolve since the time of Expo '74. Today, several states have passed laws prohibiting such balloon releases to reduce the impact on wildlife that might ingest the balloons and to protect power lines.

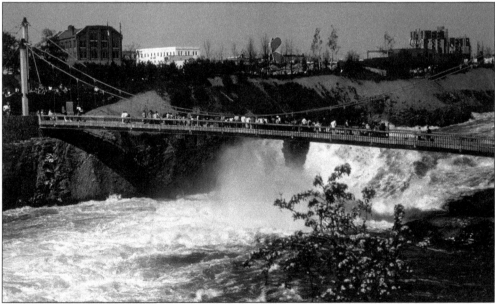

Several footbridges were added to provide easy access across the river, thereby eliminating potential bottlenecks. They were popular for their views of the river but were especially crowded on the hotter days of the fair, as guests paused to cool off in the welcoming mists coming off the falls. Concerns from parents and school groups about easy access to the river forced the Expo builders to quickly add additional fencing shortly after opening day.

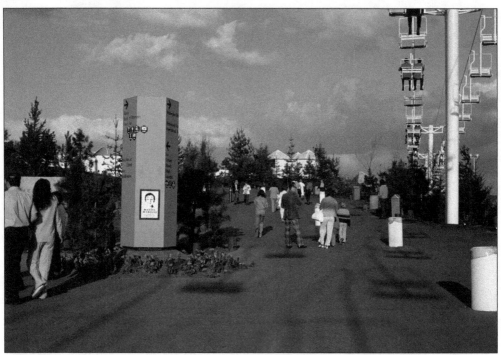

The Expo designers went to great lengths to make the site pedestrian friendly. There were large walkways designed to hold the expected crowds on the busiest days, easy-to-spot signposts, and lighting fixtures built close to the ground so as not to obstruct views. Many of these fixtures were not ready at opening, making navigation at night difficult at first. Unfortunately, the planners did not think of everything, and throughout its run, Expo was criticized for a lack of restrooms and drinking fountains.

There was also a shortage of pay phones, as well as mailboxes to send postcards back home. It may seem rather quaint now, but in the days before cell phones and e-mails, this was a steady source of guest complaints. Despite these issues and complaints about the food offerings across the site, guest opinion surveys showed most visitors were overwhelmingly happy with their Expo experiences.

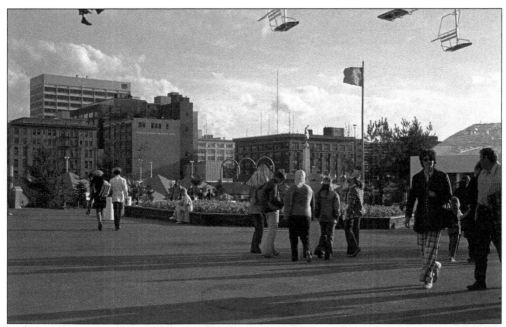

There were many open areas throughout the Expo site. Part of that was due to the fact that approximately half of the 100-acre site was taken up by the Spokane River. A more disappointing reason was that the fair did not attract the number of pavilions it had wanted. Initial studies predicted that there would be 60–75 exhibits, but there were far fewer. By October 1973, only 60 percent of the space allocated for international exhibits and 59 percent of the domestic space had been sold.

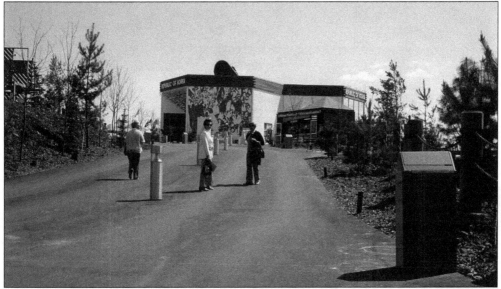

Some early critics proclaimed that Expo was a failure because the walkways were relatively wide open and uncrowded, which gave the impression that no one was coming to the event. Luckily, as other positive reviews spread the word about the various pavilions and shows, attendance grew, and soon these once empty walkways were filled with throngs of visitors. Without the wide walkways, getting through the site would have been a nightmare.

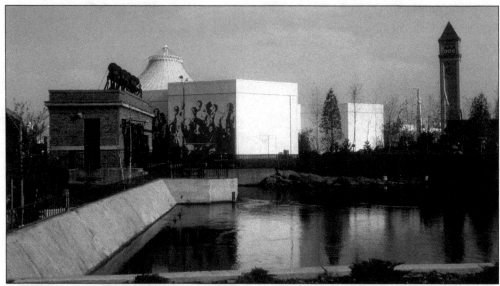

The Expo site plan often placed new buildings right next to existing structures, making for some decidedly contrasting views. Here, part of the Australia pavilion was squeezed in next to part of the hydroelectric power plant built in 1922. As the fair ended, numbers appeared once again on the clock tower, this time counting down the days until Expo ended, placing this as October 29, 1974. By the time Expo '74 ended nine days later, it had attracted 5.6 million guests.

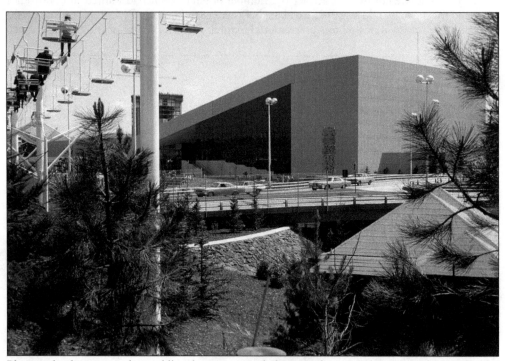

Placing the fair site in the middle of a major city led to another complication—the need to let regular traffic pass through the area. Partially burying Washington Street in a tunnel through the fair solved that problem. Here, cars pass by the Washington State pavilion and the A&W Sky Float ride.

Although it was impossible to completely hide the outside world, the Expo designers did a masterful job drawing visitors' attention away from it as much as possible. Walkways were ringed with rustic fences and newly added trees, and small lighting fixtures at ground level helped encourage a feel of being out in the country rather than in the heart of Spokane.

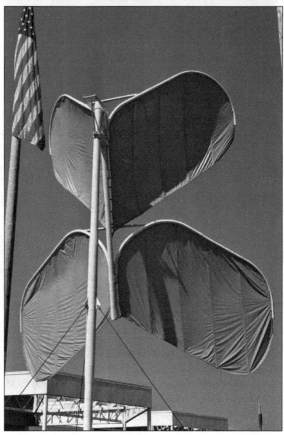

The Expo site was divided into five color-coded areas, and a massive, cloth, butterfly-shaped sculpture was placed near each of the gates as a guide to help guests find their way around. Each of the butterflies was color coordinated with the nearby gate, as were the surrounding flowers. Stronger-than-expected winds forced the replacement of the original solid coverings with a lighter mesh fabric during the fair. Only one of the butterflies has survived to today, but without its cloth panels.

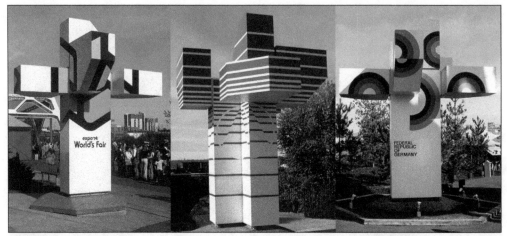

Colorful signposts marked each of the major pavilions. They all were shaped the same, described by some as modern-day totem poles, but each featured widely varying artwork based on the sponsoring organization's logo or national flag. Seen here are the signposts for the Expo '74 headquarters building, a tribute to the Bureau of International Expositions, and the Federal Republic of Germany. (Courtesy of Ellen McFadden.)

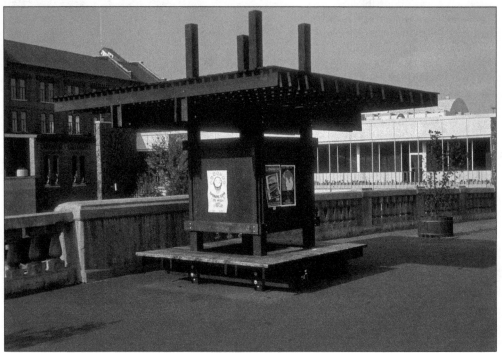

While many recent world's fairs, theme parks, and malls had used electronic billboards to advertise events and shows, Expo '74 used a much-less-technical approach that was designed to match the fair's ecologically friendly theme. Simple wooden kiosks were set up across the site to hold posters. On one of the flyers seen in this October 29, 1974, shot is a sign for a commemorative book to be released when Expo would close in a few days.

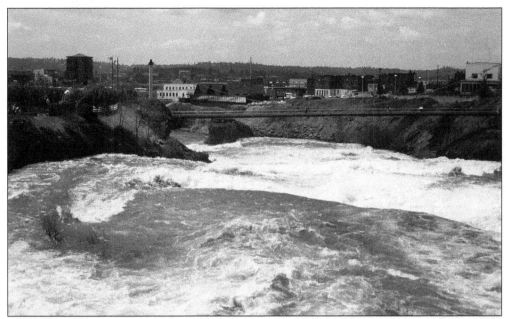

Many of the articles written about Expo '74 praise the developers for locating it so close to a powerful waterfall. The preceding winter had seen an especially heavy amount of snow in the surrounding mountains, making for an impressive display of nature's power during the early days of the fair, which coincided with the spring runoff. The Expo publicity team must have been quite happy with the results.

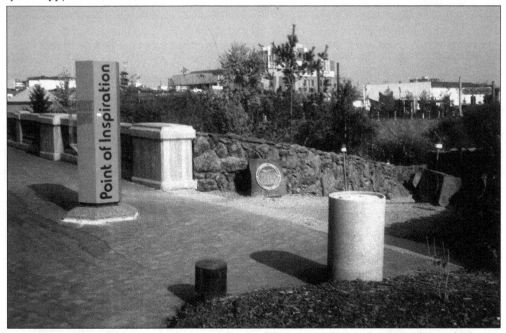

Inspiration Point, which was also known as Point of Inspiration, featured a series of 18-inch plaques set into rocks that honored famous Spokane pioneers. The Spokane Christian Coalition raised the $20,000 needed to create the scenic overlook along the river. The area proved to be a popular spot for those taking pictures of the United States pavilion across the river.

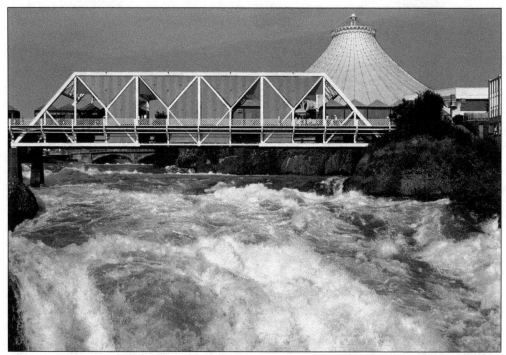

The site designers found a creative way to deal with the Howard Street Mid-Channel Bridge, which dated back to 1909. Originally used for vehicle traffic, it was a pedestrian bridge during Expo but was far wider than what was needed, and it did not mesh at all with the more futuristic pavilion designs. The solution was to garb it in brightly colored cloth panels and to add small shops along it, passing it off as homage to the famous Ponte Vecchio in Florence, Italy.

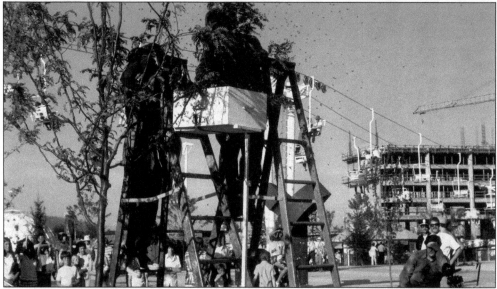

It is interesting to see that the environmentally themed fair suffered at least one ecological problem during its run. Beekeepers had to be called in to remove a swarm of bees that followed their queen into a tree one day in June 1974. Fortunately, the bees kept their distance from the watching guests and no serious incidents were reported.

Two

THE INTERNATIONAL AND STATE PAVILIONS

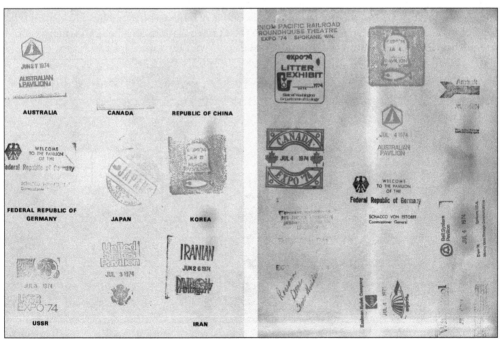

Expo '67 in Montréal introduced the concept of collecting "visa" stamps from the pavilions in a "passport" to encourage visits to as many of them as possible. Expo '74 sold a booklet featuring the official US commemorative stamp with a page to collect visa stamps. Somehow, planners neglected to allow for stamps from the commercial pavilions and the Philippines, but an enterprising visitor added some to the envelope that held the brochure. (Courtesy of Robin Adams.)

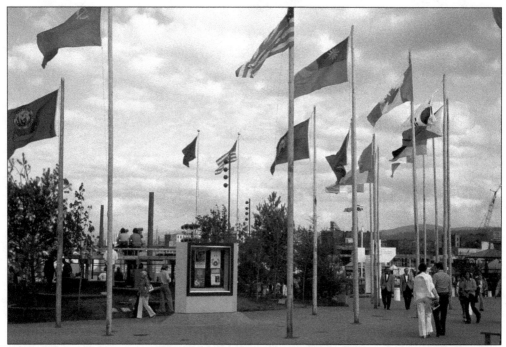

One of the things that sets a world's fair apart from a county or state fair is the presence of pavilions from around the world. Although a small fair, Expo '74 did have exhibits from Australia, Canada, Iran, Japan, West Germany, the Philippines, the Republic of China, the Republic of Korea, and the Soviet Union. Each of these flags was included in the Plaza of Nations located at the International Amphitheater. Souvenir hunters managed to steal six Soviet flags during Expo.

The largest international display was called Canada Island. Longtime Spokane residents were amazed to see how the former Cannon Island had been recontoured for the fair. Once a flat and barren stretch of deserted railroad tracks, it now featured wooded hills and a variety of imported wildlife. Hundreds of Canadian evergreen and deciduous trees were imported to transform the site—and to make it feel like a real forest, Canadian squirrels, chipmunks, and marmots were also imported.

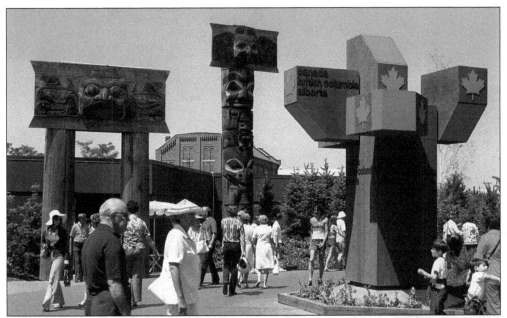

Originally, all of Canada was to have been represented at Expo, but budget worries led to a cancellation of the planned national pavilion. Happily, the provinces of Alberta and British Columbia decided to participate on their own. Here, a towering totem pole and carved gateway arch decorate the entrance to the exhibits, with one of the modern totem pole–styled pavilion markers on the right, painted in a wooden motif to match the rustic feel of the island.

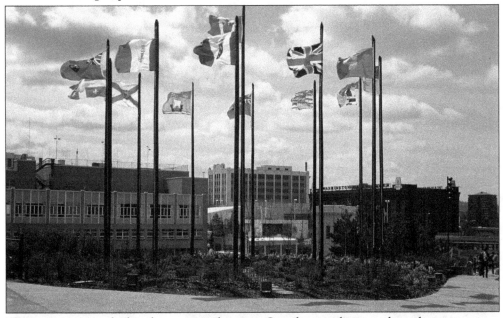

The Expo organizers had made a major push to get a Canadian pavilion in order to draw more guests from across the border, but those plans were dashed when the Canadian government withdrew in July 1973, temporarily leaving the newly renamed Canada Island without any Canadian shows. However, the provincial pavilions were a hit, and the area was popular with guests from both sides of the border. The other provinces were only represented by their flags.

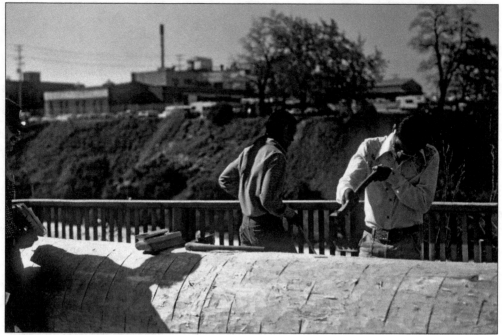

Frank Charlie and Joe David of the Nootka tribe from Vancouver Island spent several months carving a full-size totem pole along the riverbank outside the British Columbia pavilion. Both men have since received critical acclaim for their works, many of which are in museum collections. The totem pole, which features an environmental tale told through its symbols, was finished during Expo '74 and is still in the park today.

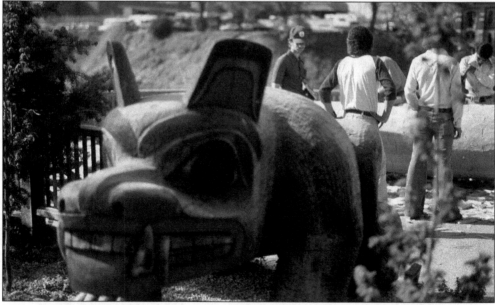

Other examples of First Nations art were on display both outside and inside the British Columbia pavilion, a series of three interlocked hexagons designed to blend into the surroundings. Inside were a number of multimedia presentations produced by Canadian Kinetoscope of Vancouver that showcased moments in the province's history, as well as life in modern times.

Following the cancelation of the planned Canadian pavilion, leaders in Alberta scrambled to find a way to somehow take part in Expo '74. In late 1973, they announced they would be there with a $150,000 amphitheater nestled in the rocks and trees of the newly contoured island. The stage was used for both Canadian and other performers. Here, Mark Wenzel, part of a Los Angeles–based mime troupe, performs on the circular stage, with the British Columbia pavilion off to the right.

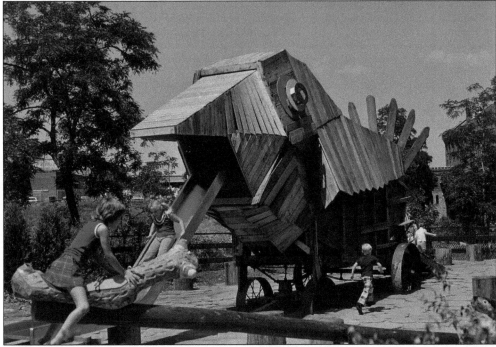

Even with futuristic displays and imaginatively designed buildings, sometimes there is nothing more fun than a playground full of slides and rides. The Canada Island playground was designed with Expo's eco-friendly theme in mind; all of the components of this fanciful giant bird were recycled materials. A huge hit with the younger set, the nearby benches were undoubtedly just as popular with their parents.

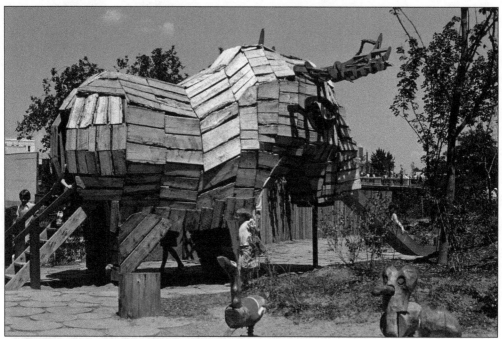

Several newspaper articles commented that there was not a great deal of interest at Expo for the younger set, as most of the exhibits focused squarely on environmental themes presented in serious and studied tones. There were some rather pricey kiddie rides in the amusement area and some baby animals in one pavilion, but the lack of child-friendly exhibits made the slides on Canada Island especially popular with families.

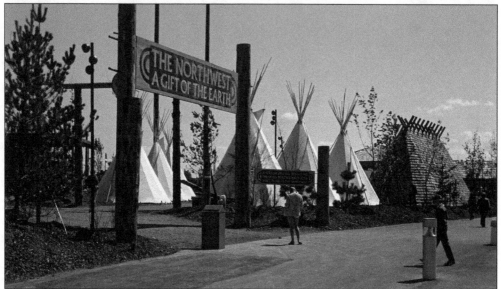

"The Northwest: A Gift of the Earth," a three-acre area, was to have been hosted by the Smithsonian Institution, but the museum dropped out shortly before opening day. The fair then organized a series of performances by individuals and groups from across the Northwest, most of whom came there at their own expense to be part of the fair. The exhibits changed throughout the Expo season, making it a hit with repeat visitors eager to see what was new.

Japan had a well-received pavilion that focused on how important the environment was to be able to house its 100 million residents in only 142,811 square miles (slightly smaller than the state of California), not all of which was suitable for daily living. The 23,500-square-foot pavilion featured a multiscreen film and a wide range of displays on the country's history, modern life, solutions to environmental problems, and, in a bow to tourism, a look at the many leisure activities available on the island nation.

Outside was a traditionally styled Japanese garden, designed to make the most use of a small space—but with a twist. This one used plants from the Northwest, arranged by Japanese artists, to demonstrate both the spirit of cooperation between the two countries and to show how man can benefit from working closely together to protect the environment. Extra sprinklers were needed because the plants chosen used more water than a typical Japanese garden.

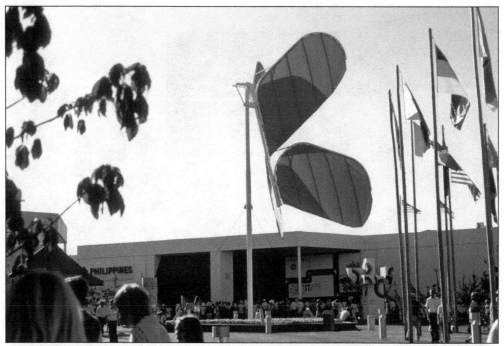

Here, a yellow butterfly and the flags of the international exhibitors fly outside the 4,750-square-foot Philippines pavilion. The Philippines was an important trading partner for the Northwest and had previously had a major presence at the 1962 Seattle World's Fair, where three separate pavilions touted its commercial products and natural resources. For Expo '74, though, the emphasis was on a new industry—tourism.

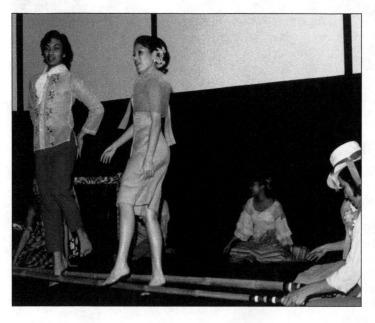

One of the demonstrations of Filipino arts and costumes was the tikling dance, named for a bird that destroys rice fields. Farmers use bamboo traps to try to snare these unwelcome pests, but the birds are very fast and can often pull their feet out as the traps are sprung. Here, a pair of dancers is showing how quickly they, too, can evade the bamboo poles. Behind them are screens used for presentations on life in the Philippines.

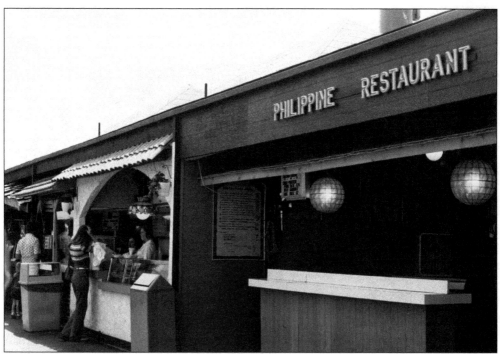

Like most of the international exhibits, the Philippines pavilion did not feature its own restaurant. Instead, there was a snack bar in what was called the International Food Fair. The Expo organizers tried to deflect criticism about the overall lack of dining opportunities by suggesting a walk to the restaurants in nearby downtown Spokane, but with the large crowds coming to Expo, they were often filled to capacity, something that was not well received by the local residents.

Many of the snack bars, small restaurants, and concession stands proved to be a problem for the fair organizers. In addition to ongoing complaints about prices and poor-quality products, it was discovered that many of these outlets were not fully reporting their sales, thus paying less in royalties than had been predicted. This financial shortfall posed a considerable challenge for the fair and led to a series of disputes with the master concessionaire and its subcontractors.

West Germany took a very unusual approach to its look at the environment. All countries, the exhibits stated, were guilty of pollution, but West Germany was especially guilty. Rather than just being self-shaming, the exhibits proclaimed that West Germany had recognized the sins of its past and was well on the way to being a world leader in reducing pollution and waste. Films played on 18 small screens throughout the area to promote the concept.

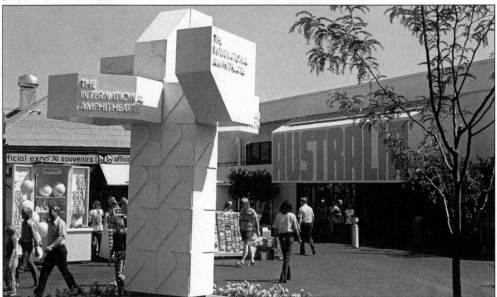

Visitors to the Australia pavilion were greeted with an impressive glass scale model of the new Sydney Opera House just inside the building entrance. A staff of 40 was on hand to answer a steady stream of questions about life in Australia and to promote tourism. Australia's most popular attraction, though, was Helen Reddy, who was then the top-ranked female recording artist in the United States. She appeared in concert at the new Spokane Opera House to help celebrate Australian National Day, one of a series at Expo celebrating each nation exhibiting.

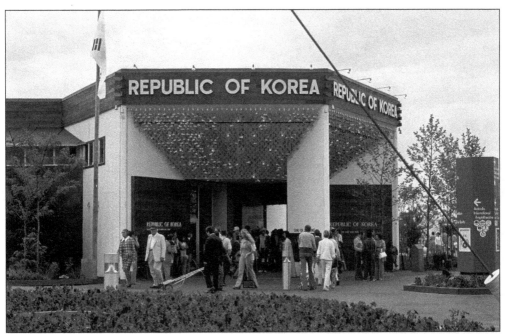

The Republic of Korea, better known to most Americans as South Korea, decorated the front of its pavilion with hundreds of small wind chimes. In addition to providing some soothing sounds, the movement of the chimes helped break up the surface of the pavilion's otherwise empty walls and attracted the gaze of many fairgoers. Those coming inside were invited to ring a ceremonial gong to announce their arrival.

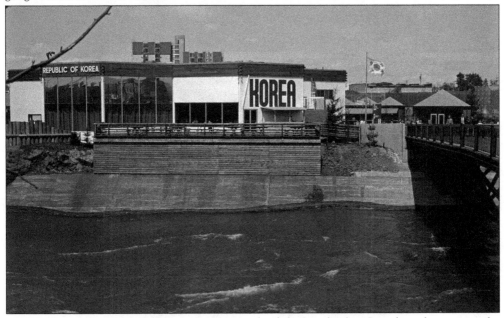

South Korea had one of the largest international exhibits at the fair. Seen here from across the Spokane River, the facility included a large theater that featured performances by groups from South Korea and from Korean organizations across the United States. A barbecue restaurant was one of the most popular eateries at Expo.

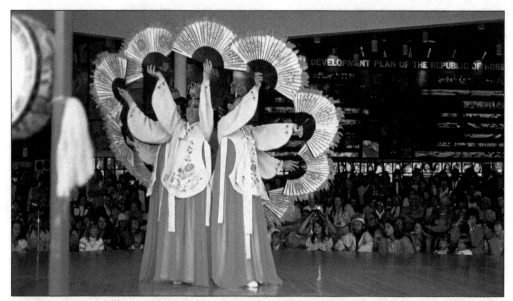

Static displays and films promoted the industrial side of South Korea with examples of how the country was tackling industrial pollution, but there were many live performances as well. The self-defense art of Tae Kwon Do was demonstrated several times each day, and there were numerous dance and musical shows.

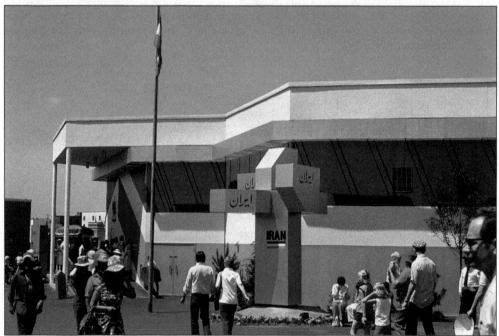

Iran's pavilion was actually built in large part by a team of 15 Czechoslovakians. The brightly colored building, styled after the nation's flag, housed four exhibit halls with a wide display of ecologically themed exhibits, including a seven-minute film that was surrounded by six screens of changing photographs. Large photomurals and models were of interest primarily to older visitors, but guests of all ages reacted enthusiastically to a puppet show that provided a light-hearted look at many of Iran's man-made wonders.

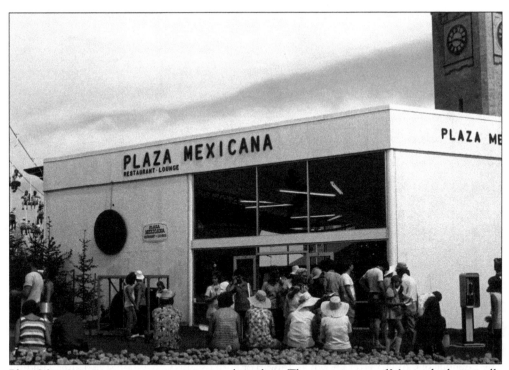

Plaza Mexicana was not a true international pavilion. The government of Mexico had originally agreed to participate in the fair with an impressive exhibit of pre-Columbian artifacts but later withdrew due to the cost. Desperate to avoid announcing that a major international participant had pulled out, the fair organizers flew to Mexico City hoping to salvage the deal. The result was a commercially sponsored exhibit that was generally panned.

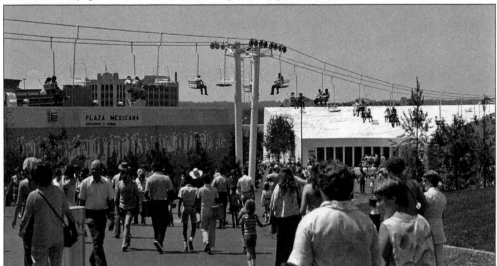

For a while, it was uncertain if Plaza Mexicana would open at all, and when it did, there was not even a name on the building to alert visitors to what was inside. The lack of any Mexican theme in the graphics on the wall did not help draw crowds inside, so a small sign was hastily slapped onto the 4,250-square-foot building to advertise that it was a restaurant and lounge. There was also a small tourism counter as well as several industrial displays.

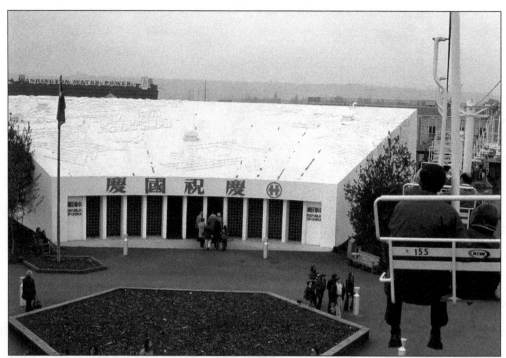

The Republic of China, better known as Taiwan or Formosa, had a pavilion styled after a folding fan. Inside was a 24-minute multiscreen film presentation dubbed *Electrovision*, which employed 16-millimeter film and 28 slide projectors, all controlled by computer, and a giant 180-degree screen. The presentation traced Chinese inventions from ancient times to the present, a look at Chinese arts, and the tourism venues of the island nation.

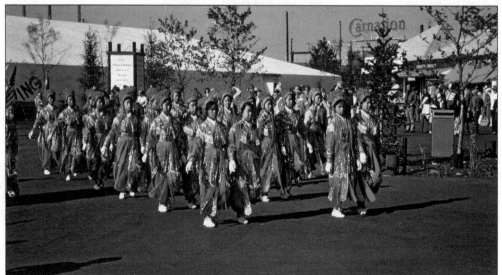

In addition to the performers employed at the fair, there were also performances by Chinese groups that traveled to Spokane from across the United States, Canada, and from Taiwan. The Taiwanese government spent a considerable amount of money to position itself as *the* China; no mention was made at Expo of mainland China, which was enjoying a considerable amount of attention elsewhere following President Nixon's visit there in 1972.

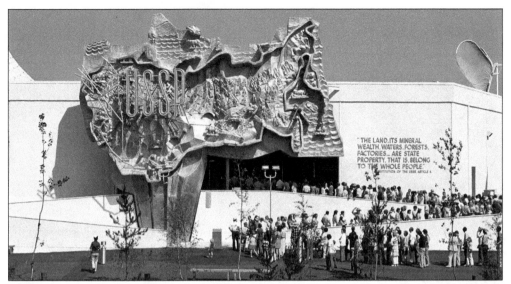

The most impressive international exhibit was the Soviet Union pavilion, which measured in at 52,000 square feet. Visitors were encouraged to visit in the early morning or at night, for despite spending a huge amount on the building, the Soviets had neglected to include air-conditioning. A quote from the USSR constitution at the entrance proclaimed, "The land, its mineral wealth, forests, factories . . . are state property, that is, belong to the whole people." This heavy-handed approach was apparent throughout the pavilion.

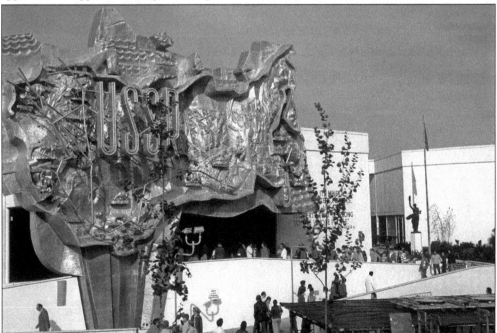

Hanging over the entrance was a 60-by-30-foot aluminum relief map that weighed 4,500 pounds, which was said to show how the Soviet Union planned the locations of its industries to minimize their impact on the environment. No mention was made as to how the location of natural resources might have factored into the equations. It is doubtful that many visitors understood the message the intricate sculpture was intended to convey.

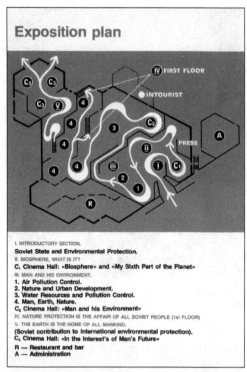

Exposition plan

Getting the Soviets to participate was a major coup as it marked their first appearance at a US-based fair since 1939. While relations between the Soviet staff and its American hosts were generally cordial, the Soviets were not allowed to travel more than 25 miles from Spokane. They also complained about "suspicious" flights over the pavilion by B-52 bombers based at nearby Fairchild Air Force Base.

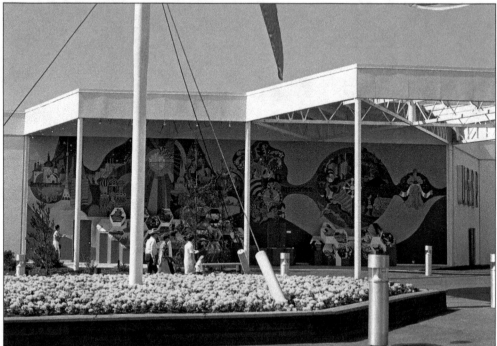

One of the walls of the pavilion was decorated with a colorful mural saluting Intourist, the country's official tourism bureau. Artwork based on iconic Soviet themes was combined with photographs of tourist attractions from across the country. Would-be visitors were invited to come inside, where a fully staffed travel agency was available to help plan and book trips to the Soviet Union.

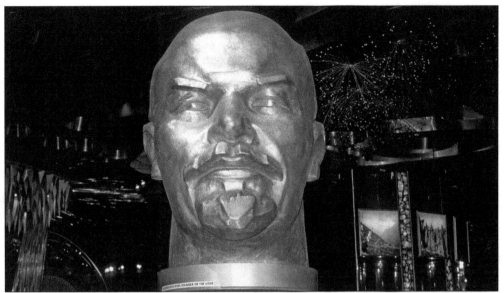

The official theme of the pavilion was "The Role of the Soviet State in the Preservation of Nature and Effective Use of Natural Resources." Once inside, guests were treated to a giant sculpture of founder V.I. Lenin, with exhibits about his life and his "lifelong interest in the conservation of nature." More than a few news reports remarked on the rather stern image of the former Soviet leader.

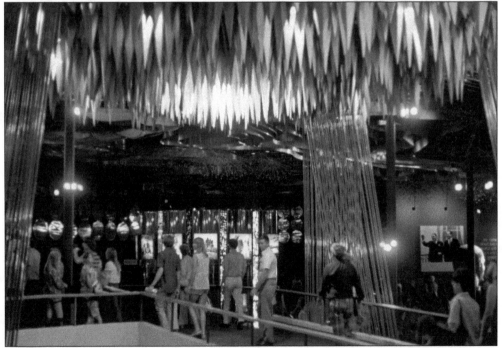

Guests wandered through a myriad of exhibits on their way to see the five films featured at the pavilion. In *The Biosphere*, a multiscreen film touted the concepts espoused by ecologist V.I. Vernadsky and other Soviet scientists. He is perhaps best known for his 1926 book of the same name, which is still in print today. In 1943, Vernadsky was awarded the prestigious Stalin Prize for his work on environmental issues.

Other films included *Biosphere and Man*, which showed how mankind was tapping natural resources such as hydro and thermal power, and *My Sixth Part of the Planet*, a look at the natural wonders throughout the Soviet Union. Exhibits in the Man and His Environment Hall highlighted Soviets efforts to reduce pollution and erosion, and to improve waste recycling.

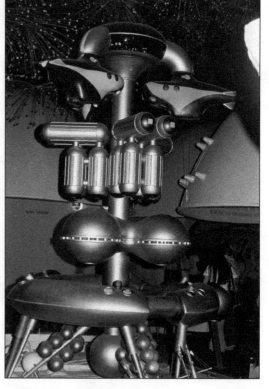

Some of the displays were rather cryptic and hard to decipher. Many of them were presented in a "hard sell" approach that emphasized the superiority of Soviet technology and the benefits of a communistic society. This unusual-looking model apparently espoused Soviet advances in undersea research and mining.

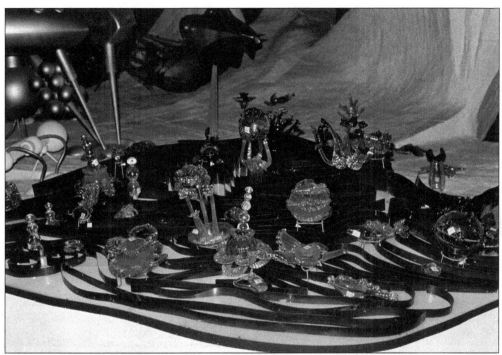

The undersea display also included a whimsical touch, with colorful glass figures of fish, anemones, and other sea creatures. Overall, there was little in the pavilion about Soviet life or arts, but there was one section that exhibited a number of craft pieces. The Soviets did host a number of well-received events, including dance, skating, and basketball performances, and six sold-out shows at the 5,000-seat Spokane Coliseum featuring Olympic gold medal gymnast Olga Korbut.

Visitors hoping to bring home a set of Russian nesting dolls or reproductions of Fabergé eggs undoubtedly left disappointed, but there was a large supply of brochures on Russian ecological practices that they could pick up for free. The Soviets made a concerted effort to showcase their environmental advances, but it appears they could have used some help from the advertising firms on Madison Avenue. The Soviet literature was rather dry, to say the least.

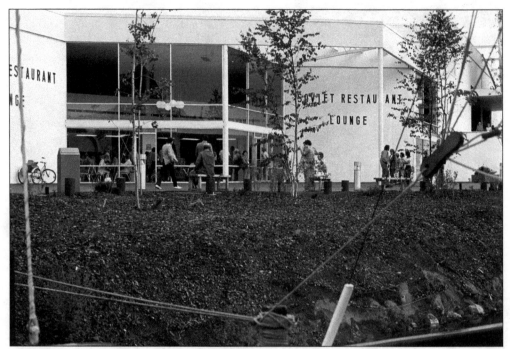

The restaurant at the Soviet Union pavilion was the largest one at Expo, with a large seating area located on two levels. Voted as the most popular part of the pavilion in visitor surveys, the restaurant operated cafeteria style, which helped speed crowds through the often jammed facility. Tables facing the windows were especially popular, for they offered views of riders on the A&W Sky Float as well as the Washington State pavilion.

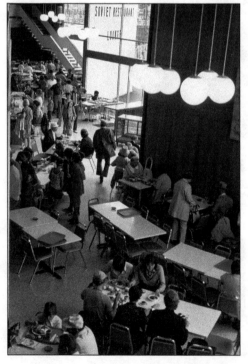

While most of the food at Expo was rather plain and heavily skewed towards hamburgers and hot dogs, the menu at the Soviet pavilion included entrees such as Ukrainian stewed chicken, skewered lamb, and beef stroganoff. The restaurant was also popular for its bar, said to be the scene for frequent drinking contests between the Soviet staff and the Americans at Expo. It is conceded that the Soviets usually won.

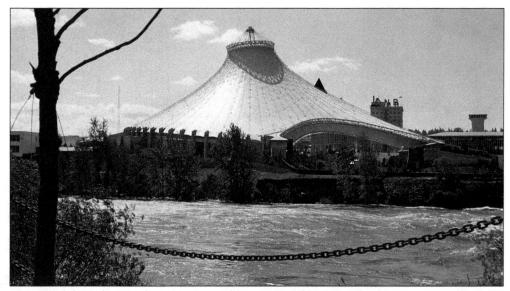

Expo '74 did not have a theme structure like most world's fairs. There was no towering Eiffel Tower, no Trylon and Persiphere, nor a Space Needle or Unisphere. Perhaps the most iconic structure at the fair was the United States pavilion, a tentlike structure prominently located along the riverbank. Together with the Great Northern Clock Tower, it was widely featured on publications and merchandise.

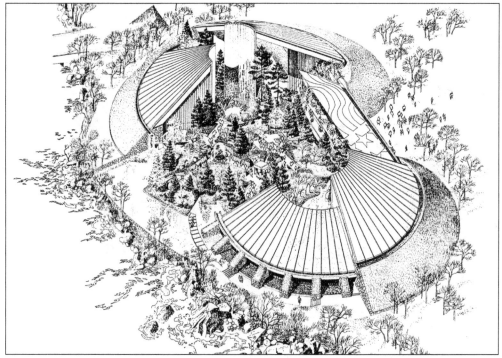

As large and impressive as it was, the initial plans for the pavilion had been even more ambitious. A large man-made forest would have been located in the center of the pavilion, with exhibits interspersed between the trees and in the buildings surrounding the glade. Several variations on this design were produced but were eventually canceled due to ever-increasing costs.

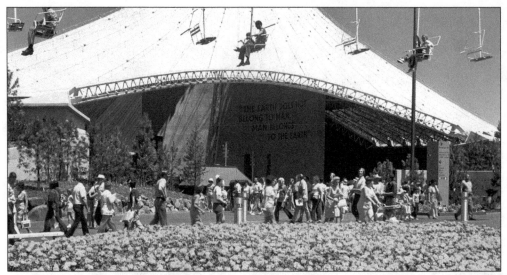

The final design of the $11.5 million exhibit, the largest at Expo, replaced the planned forest with a smaller display area topped by a gleaming two-acre vinyl roof. There was also an 850-seat theater and a 5,500-square-foot exhibit hall called the Environmental Action Center. Located approximately at the center of the Expo site, it was the largest pavilion at the fair.

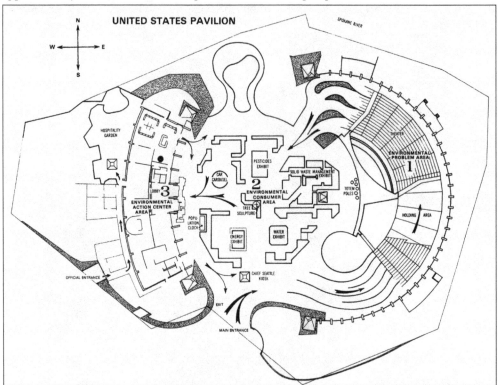

Most of the exhibits were in the 17,000-square-foot courtyard at the center of the structure. There were separate areas for water, energy, solid waste, air, pesticides, and wood products—all tied together under the unifying theme of "Man and Nature: One and Indivisible." The pavilion's staff was the largest at the fair, with 55 tour guides plus a support team.

A massive engineering and construction job was needed to support the 12-ton roof over the central part of the pavilion. A 14-story steel mast and 4.6 miles of steel wire cables were used, raising the total roof weight to nearly 200 tons. A 50-foot-wide opening at the top of the mast helped air circulation under the roof and allowed heat to escape without the need of a mechanical ventilation system.

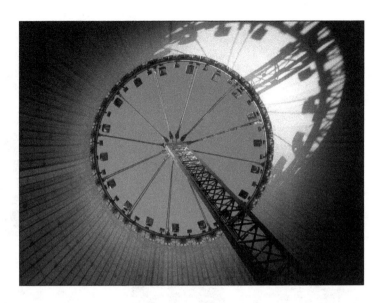

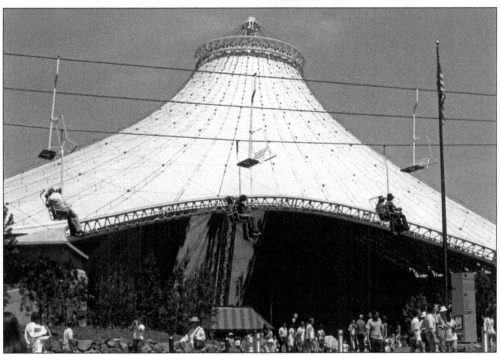

The main entrance to the pavilion was under a soaring arch set into the roof. Guests passing by on the walkway in front of the pavilion or on the A&W Sky Float aerial tram were treated to views of the central exhibit area. A small booth at the entrance provided information on the exhibits inside, with more detailed publications on environmental issues available at the Government Printing Office bookstore inside the Environmental Action Center.

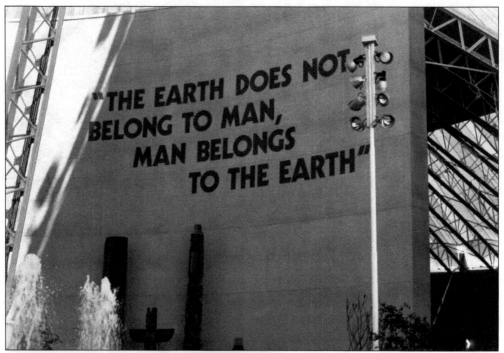

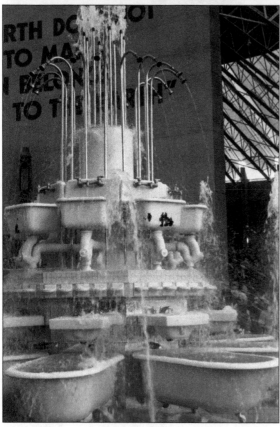

This quote in two-foot-tall letters by Chief Seattle of the Suquamish Indians was in response to an offer by the US government in 1854 to buy the tribal lands. Political commentators took delight in comparing the vast difference in this philosophy with the quote on land ownership at the entrance to the Soviet Union pavilion. A display of totem poles beneath the quote was another testimonial to the Native Americans who had lived in the area before the arrival of white settlers.

Many visitors undoubtedly did a double-take when they first saw this very unusual fountain. Constructed solely of bath tubs, sinks, and other plumbing fixtures, it was intended to point out how much water was wasted each year through leaky faucets and broken pipes. Signage showed how much water was used each year by the average home on items such as baths, toilets, cooking, and keeping the lawn green.

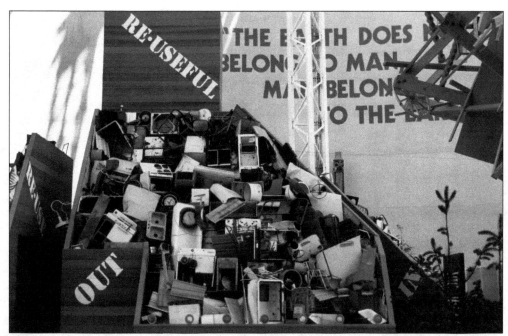

The need to recycle items instead of dumping them in landfills was demonstrated in a massive pile dubbed "Trash Mountain," comprised of car parts, bedframes, used appliances, old clocks, and even the proverbial kitchen sink. Each of these was made of metal and plastic that could be recycled and reused, but that now common practice was still quite revolutionary in 1974.

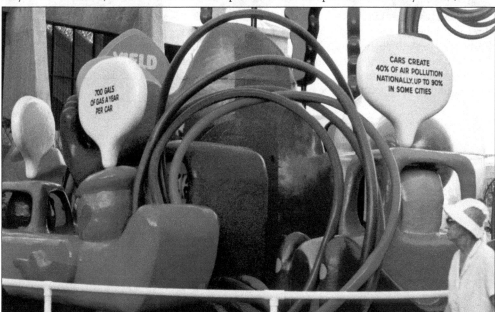

An entire display was devoted to pollution caused by automobiles and their insatiable appetite for fossil fuels. Well before the days of hybrid or electric cars, the Car Carousel exhibit shared the message that more efficient cars needed to be part of an overall solution that included more mass transit systems. With memories of gasoline shortages caused by the 1973 oil crisis still all too vivid, many guests paid particular attention to this part of the pavilion.

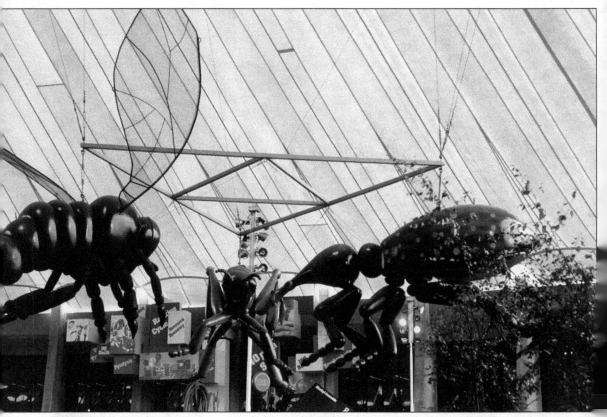

Three enormous plastic insects suspended from the ceiling were part of a display on insecticides. While many of these chemicals had been useful to control voracious agricultural predators, overuse had led to contamination of the soil and water in many areas. Even worse, the food chain had suffered, as birds that ate poisoned insects became inadvertent victims. The exhibit suggested more natural ways to control these unwelcome pests.

Unbridled population growth was another cause of environmental concern. The Population Clock was linked to a conveyor belt that showed the amount of natural resources consumed by the average American in his lifetime and the resultant trash. A placard on the clock explained that "every time the clock strikes, another American baby is born." It struck every 10 seconds.

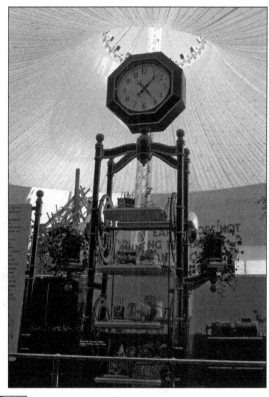

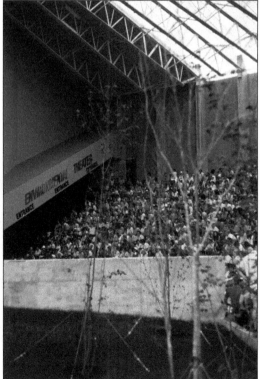

The crowd seen here is waiting for the pavilion's main attraction, a 22-minute film shown on the largest theater screen in the world, 65 feet high and 90 feet wide. *Man Belongs to the Earth* was the first movie released in the 70-millimeter IMAX format, which uses film three times larger than the once popular Cinerama system. Produced by Paramount Pictures, the film features Chief Dan George in several vignettes with narration throughout by James Whitmore. The film amazed audiences with its size and clarity, beginning with a stomach-turning plane trip through the Grand Canyon that is so realistic some guests needed airsickness bags. Two major problems it explores are smog and strip-mining; scenes of heavy smog inundating Denver, Colorado, prompted complaints from civic leaders and an apology from the Expo staff. The film can be seen online at https:// archive.org/details/govntis.ava03671vnbl.

The final part of the United States pavilion was the Environmental Action Center. Designed as a permanent building to be retained for the planned post-Expo park, it showcased the federal government's approach to environmental issues, from the Rivers & Harbors Act of 1869 to then recent environmental legislation.

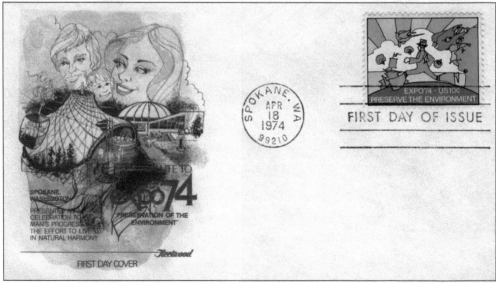

The United States released a postage stamp to commemorate Expo '74. Artist Peter Max was commissioned to create a piece he named *Preserve the Environment*. It features a figure the artist named "Cosmic Jumper" striding through a landscape of fanciful animals, a ship, sea, and clouds, with the image of a woman dubbed "Smiling Sage" looking on approvingly from the right side. The stamp went on sale on April 18, 1974, to help draw interest to the upcoming fair.

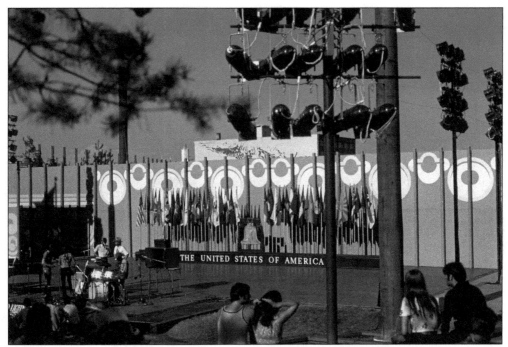

Most cities that host a world's fair will have a pavilion or exhibit there to help draw attention, and possibly new businesses, to the area. Spokane went in a different direction for Expo '74, joining with the Boeing Company to sponsor the International Amphitheater. Located at the eastern end of Havermale Island, the facility was designed to become part of the post-fair park.

The amphitheater was used for a wide range of activities. All of Expo's official ceremonies were held there, including the special days set aside to honor the international pavilions and corporate sponsors. While the new Spokane Opera House was used for the biggest stars and had separate admission fees, the amphitheater was a free venue.

The amphitheater was advertised as having 1,200 seats, but in actuality, guests sat on wooden benches that were part of the retaining walls on the raked slope. Some shades were added following complaints about hot conditions on sunny days. Nighttime performances were especially popular on the hottest of days.

Washington had the largest of the state exhibits and one of the few buildings designed for permanent use following the end of Expo. It included the Spokane Opera House, which hosted a wide variety of performances, a hall of ecologically themed video games, an art gallery with works by US and Canadian artists, and *About Time*, a film that shows how mankind has lived in harmony with nature since the earliest days of recorded history.

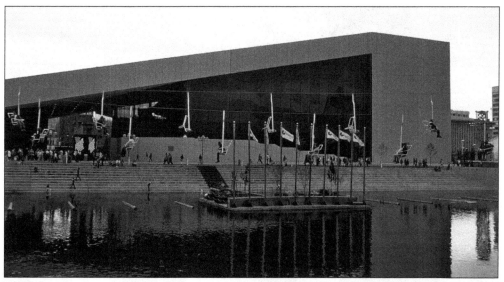

Though it was one of the few elements of Expo '74 that was designed for long-term use, parts of the $11.9 million pavilion were not quite ready when the fair first opened. Water World, an exhibit from Washington State University, was plagued by funding delays and did not open until May 11. Even then, it was incomplete, finally being finished and dedicated on May 23, making it the last major exhibit to be completed.

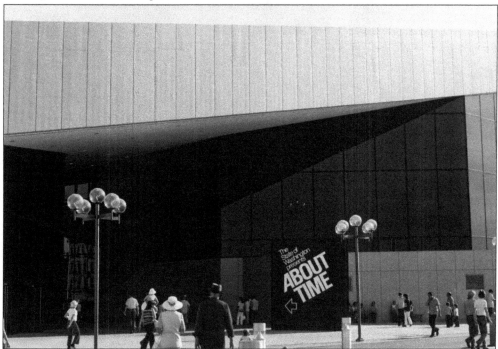

The pavilion's main attraction was the film *About Time*. It features a young girl growing up among the state's natural wonders who later moves to a busy city as an adult. There, she dreams of returning to the simpler life outdoors. The film strives to make the point that mankind has both the ability and the need to use the Earth responsibly. Rear-screen projection was combined with mirrors throughout the theater to give the impression that the film stretched off into infinity.

The Spokane Opera House was one of the key reasons the facility was so large and, in fact, was one of the major reasons funding was available to build the pavilion. Spokane had long looked for a new performing arts center, and Expo provided the perfect opportunity for it. The 2,700-seat theater actually opened on May 1, 1974, just before the rest of Expo, and is still a vibrant part of the Spokane arts community.

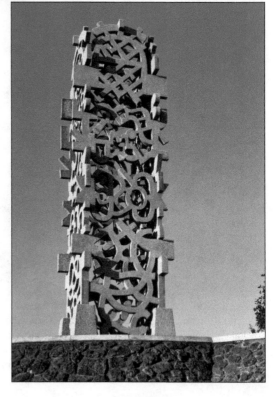

Standing just outside the Washington State pavilion is the largest piece of artwork commissioned for Expo '74, comprised of 20 concrete panels that reach 32 feet high. Sculptor Harold Balazs did not give it a name, but it is often called *Lantern*, as it is said to resemble an ancient Asian lantern, or *Ladder*, because it is easy to climb, even though illegal. A somewhat profane inscription awaits those who make it to the top.

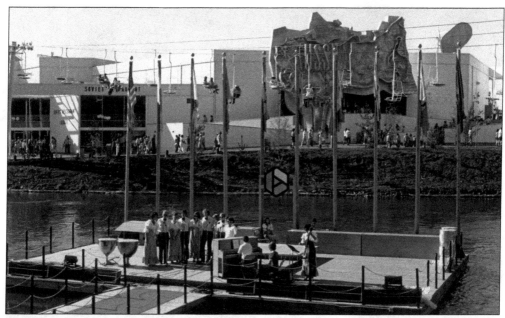

The floating stage outside the Washington State pavilion was used for many events besides the opening day festivities. It was a dramatic setting on the river with the Soviet Union pavilion and A&W Sky Float for a backdrop, and the Expo organizers kept it full with a steady stream of performers. The stage was retained following the end of Expo and is still in place today.

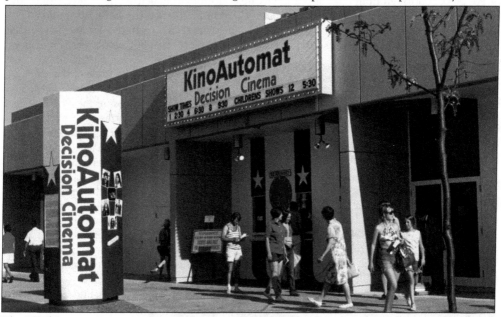

The Washington State pavilion also housed KinoAutomat, which combined live actors with a film, adding the additional twist that the audience voted at several points to decide how the show should proceed. As a result, it was billed as each performance being unique. First introduced at Expo '58 in Brussels, the Czechoslovakian production was a huge hit at Expo '67 in Montréal, San Antonio's HemisFair '68, and Expo '70 in Osaka. A new version was introduced for Expo '74, with local performers hired for the live-action roles.

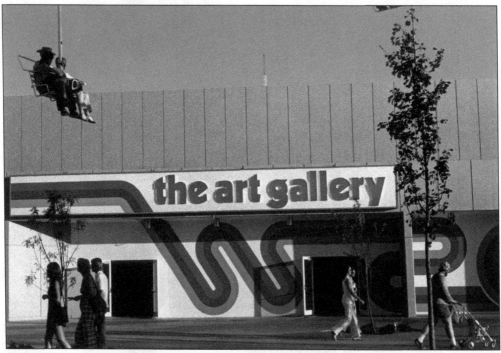

The pavilion was also home to *Our Earth, Our Sky, Our Water*, an ambitious art display comprised of 146 pieces borrowed from museums and private collectors from across the United States and Canada. The collection themes were "Man and Wilderness," "When the West Was Wild," "The Big City," and "Nature in Abstraction." Expo also held art shows scattered across the site that featured students and local artists. Press releases claimed more than 300 works were on display.

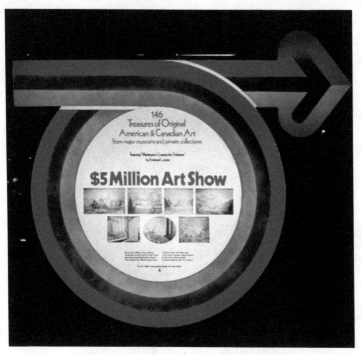

The pride of the art gallery was *Washington Crossing the Delaware* by Eastman Johnson. The painting had been sold for $260,000 at auction in New York shortly before Expo opened. This was the highest price paid for an American painting at the time. The collection also featured works by American artists Grandma Moses, Frederic Remington, and Charles Russell, and Canadian artists Paul Kane, David Milne, and Robert Whale, among others. Wealthy souvenir buyers could buy pieces by Pablo Picasso, Francisco Goya, and Salvador Dalí.

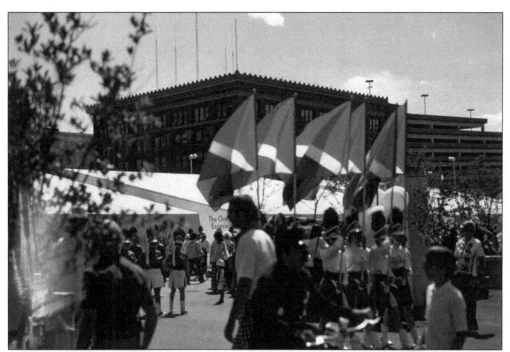

The remaining state exhibits were housed in several nondescript buildings that did not attract much attention. The Oregon Experience, seen here behind the color guard, was a financial failure, and its exhibits were seized at the end of Expo for failure to pay rent.

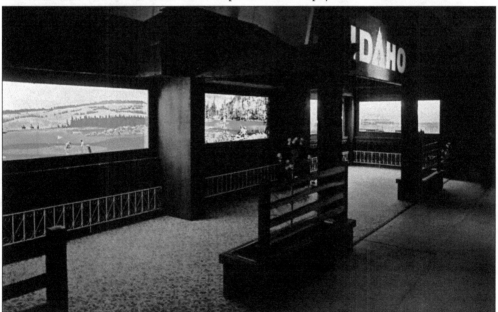

The Idaho pavilion offered little more than some pictures of the state and very few other displays. Aghast at the low crowds and even lower approval ratings from those who did visit, the state's governor ordered it closed to make way for new displays. Among them was a near life-size statue of a miner, honoring the state's mining heritage, and a second piece showing a fierce-looking eagle holding a snake in its talons. The revised exhibits did little to increase attendance.

Most of the state exhibits were last-minute affairs put together by combined state and private partnerships on shoestring budgets. Seen from outside the Expo grounds, there was little to attract much attention. The Expo organizers had expected that the neighboring states would all eagerly participate to showcase their own tourism possibilities, but instead found reluctance on their part to bring guests into Washington and thereby possibly siphon off some of their own home-state vacationers.

The rest of the states were honored at Bicentennial Plaza, said to be the first exhibit to honor the upcoming bicentennial celebrations. The first version of the American flag, with 13 stars, was surrounded by the flags of the original 13 states. The plaza received a bit of notoriety at its dedication; after what was described as a "ringing speech," the head of the bicentennial commission pushed a button to start a special fireworks show. The fireworks failed to ignite.

Three

THE COMMERCIAL SIDE
OF THE FAIR

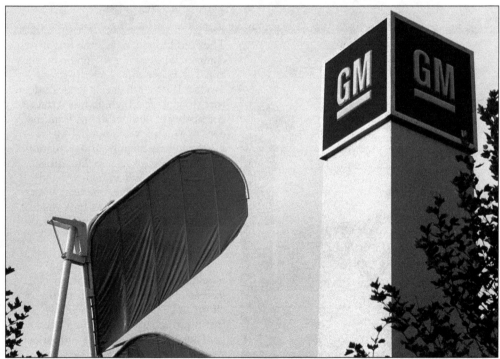

Expo '74 faced a challenge in attracting commercial exhibits due to its focus on ecological issues. Many companies were not willing to put their own environmental records up for public review, especially when they were fighting with government regulators over a wide variety of issues. While the growing attention to man's environment was good for the ongoing preservation of the planet, it was becoming an increasingly expensive public relations nightmare for most of the country's major companies. Surprisingly, the auto industry became one of the major participants in Expo '74.

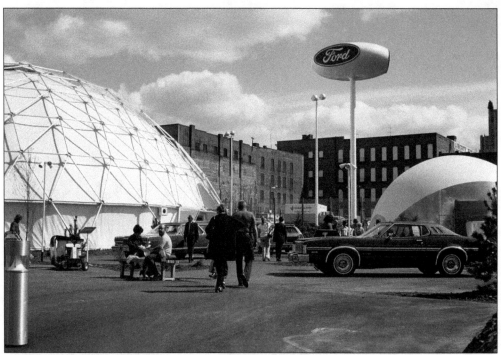

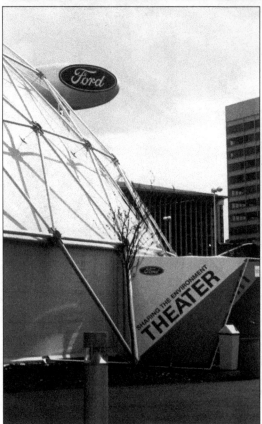

The Ford Motor Co. was the first commercial exhibitor to sign up for the fair. The Ford exhibits were housed inside a 120-foot-diameter geodesic dome that stood 45 feet high. Exhibits traced the history of outdoor living, from the days in which it was a normal way of life to modern camping and recreation. Wheeled vehicles such as Conestoga wagons, trains, and animal-powered carts had opened the American West, and today, cars and trucks have made it easy to access previously remote areas.

In addition to a film called *Sharing the Environment*, which touts Ford's efforts to be more environmentally friendly, there was a selection of new Ford automobiles, complete with price stickers, which led to some negative news coverage. Pavilion director Stanley Cousineau defended having the cars there saying, "The Ford Motor Co. is a commercial company and it is in business to sell its products. The fact we have a few of our vehicles scattered about does not detract from our exhibit."

The Ford exhibits included portions of a show called *Portable World*, which had run at the Museum of Contemporary Crafts in New York City from September 1963 through January 1974. The show included Indian artifacts and contrasted the items that the Indians had needed to live outdoors with those required by modern campers who are more used to comfort and luxury. Ford had high hopes for this custom-made camper, which it dubbed a "modern-day Conestoga wagon."

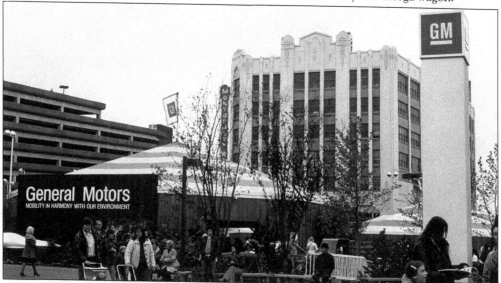

General Motors also had an emphasis on recreational vehicles, including campers and the new GMC MotorHome. A variety of science displays and *Previews of Progress*, a live stage show performed twice daily, showcased GM's efforts to reduce air pollution from cars and trucks. There were also displays on auto safety, including the new "Air Cushion Restraint System," better known today as the air bag, and on GM's contributions to space exploration. The Montgomery Ward store in the background now serves as Spokane City Hall.

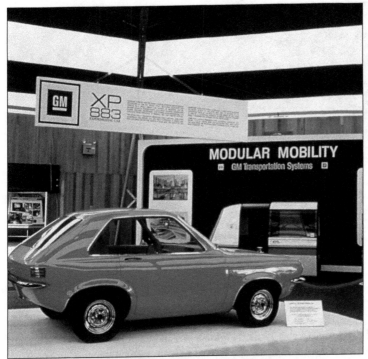

The 20,000-square-foot GM pavilion, said to resemble a blue-and-white three-leaf clover, housed a number of prototype vehicles, including the XP-898 crash-absorbing car; the XP-883 commuter car, which was also known as the Banshee II; and an inexpensive car dubbed the Basic Transportation Vehicle, which was intended for developing nations. In a rather obvious effort to tie into the Expo ecology theme, there was also a section of appliances from "Frigidaire—The Home Environment Division of General Motors."

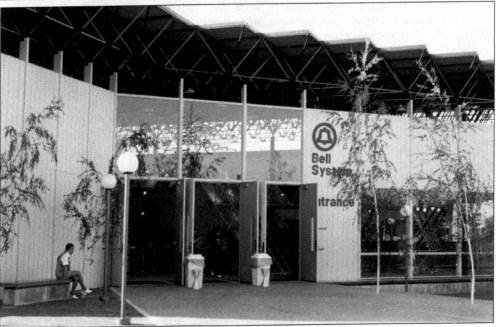

The Bell System pavilion claimed that telephone calls were good for the environment as they eliminated the need to travel for personal conversations. A five-screen film called *Movement* showed how communications had changed from caveman days to modern high-speed data services being used for business, medical, and educational purposes. For a lighter note, children could call their favorite Disney characters. Many of the exhibits were rather dull, though, including a demonstration of how to place advertisements in the Yellow Pages.

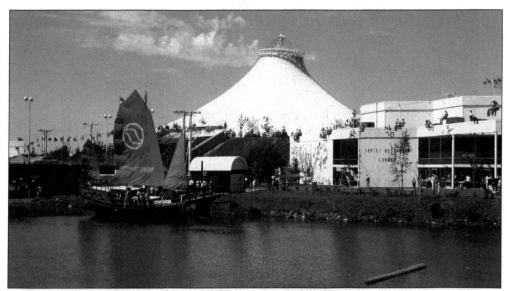

Northwest Orient Airlines had a very unusual setting for its exhibit. Bright red sails topped the *Phi Lon* (*Flying Dragon*), an authentic Chinese junk that had started life in 1925 as a fishing boat in the waters around Hong Kong. It was bought by an airline pilot and converted into a private yacht in 1964. Restored for the fair, the ship was a favorite of photographers. After falling into disrepair following the fair, it was restored in 2002 and is still sailing today.

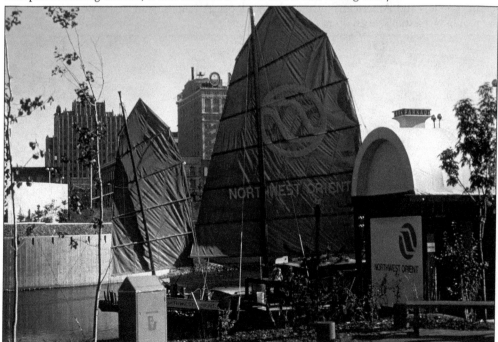

The bright red sails billowing against a blue sky and the buildings of downtown Spokane attracted the eye of many a photographer, making it a brilliant advertising vehicle for the airline. At the shore, a small kiosk provided information on the airline, including route maps, schedules, and helpful advice, including free assistance with booking or changing flights on Northwest. This may well have been the most cost-effective of all of the commercial exhibits.

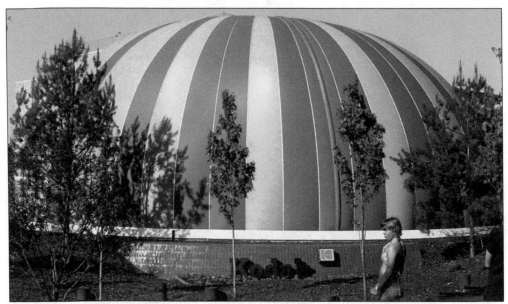

Kodak had a pavilion at every world's fair since the World's Columbian Exposition of 1893 in Chicago, and the tradition continued here with an inflatable 8,500-square-foot dome supported by air pressure. The company noted its pavilion was especially environmentally friendly as it could easily be reused elsewhere. A 200-seat theater housed a multiscreen presentation on America's scenic wonders and Americans' love of the outdoors. A helpful staff was on hand to answer photography questions, even on non-Kodak products.

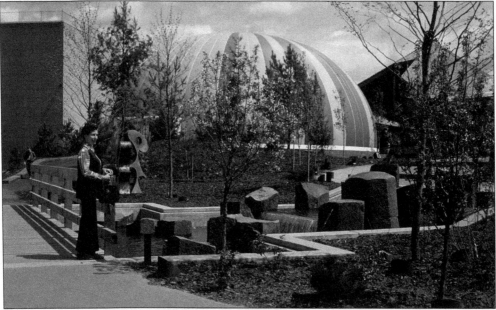

Back before the area used for Expo was originally developed for the rail yards, much of the site was known as Havermale Island. Over the years, one of the channels around the island was filled in to expand the land area, turning the former island into a peninsula. The Expo designers symbolically restored the area to an island by routing water near the site of the old channel in what was dubbed the Theme Stream, seen here passing the Kodak pavilion.

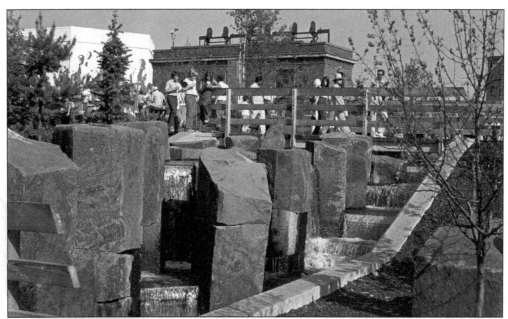

The Theme Stream was largely the brainchild of Thomas R. Adkison, the main planner for the Expo site. Large basalt blocks of native stone and small waterfalls were used to reinforce the feel of an actual streambed, hopefully to disguise the fact that the water was being pumped into the stream from a fountain and that the area was, in actuality, still a peninsula. The Theme Stream was one of the Expo features planned for inclusion in the post-fair park.

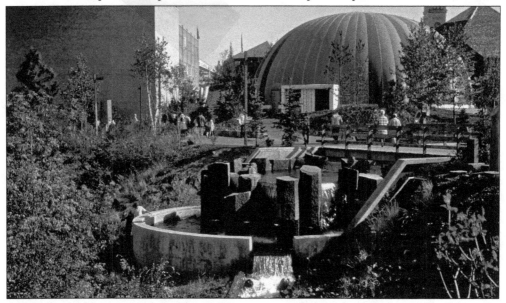

Although a path crisscrossed the Theme Stream, seemingly providing ample access to the area, it was soon discovered that the designers had overlooked the attraction the flowing water presented for visiting youngsters. No number of signs could dissuade them from following the stream past the exhibit portion as it tumbled down to join the Spokane River. Recently, the city announced plans to increase access to the water but has run into opposition from historians who want to preserve the Expo '74 design.

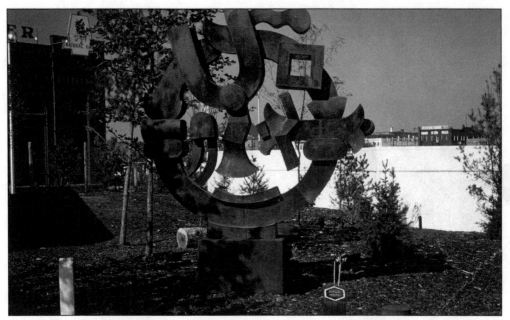

Another untitled sculpture by Harold Balazs, this one in copper, was located near the stream. After Expo, it was moved to the Washington Mutual Building at 601 West Main Street. In a playful act, Balazs added an unexpected piece of art to the Expo grounds, a fake historical marker that proudly stated, "On 27 July 1973 Nothing Happened Here." Sadly, it has since vanished. He also produced the etched glass bowls given by Expo officials to VIP guests.

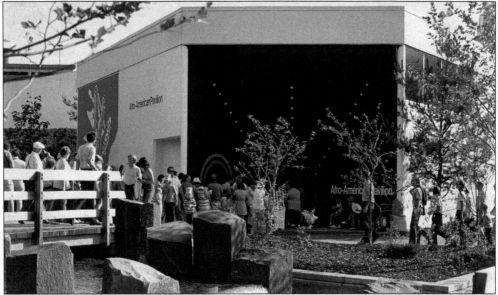

The Afro-American pavilion showcased the struggles and contributions of black Americans. Built and operated by the Pan-African Foundation, a nonprofit corporation formed for the fair, the 6,000-square-foot landscaped site explored interaction among races in the hopes of fostering better relations. A 10-minute multimedia presentation titled *Achievements Under Adversity* and art displays highlighted the history and contributions of minority citizens throughout the United States. The pavilion also included a gift shop and restaurant, both with ethnically themed offerings.

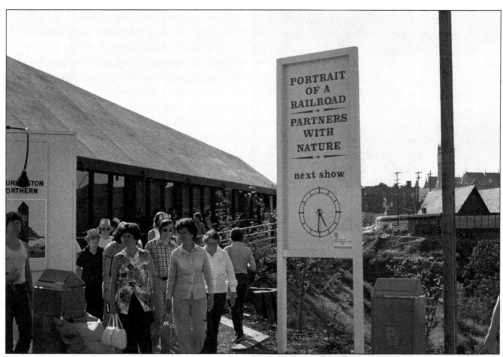

With the fair having been built on a former railroad yard, it was only fitting that it included an exhibit about rail transportation. Burlington Northern screened two films it had commissioned for Expo '74: *Portrait of a Railroad*, which is basically a 30-minute commercial about its daily operations, and *Partners with Nature*, which touts the company's then recent efforts to be a better environmental partner. The latter film tries to justify the railroad's strip-mining and clear-cutting timber businesses as being essential to the nation's economy.

The main railroad exhibit was the Union Pacific's locomotive 8444, the line's last steam engine and the largest locomotive then in use in the United States. Built in 1944, the 450-ton behemoth and coal tender were 114 feet long. The engine would later play the same role at the 1984 New Orleans World's Fair. It is still used today for special events and excursions.

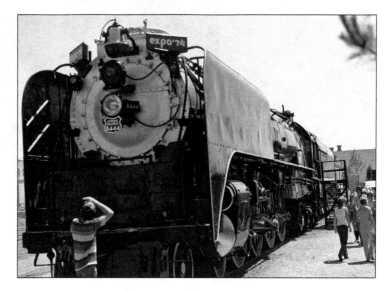

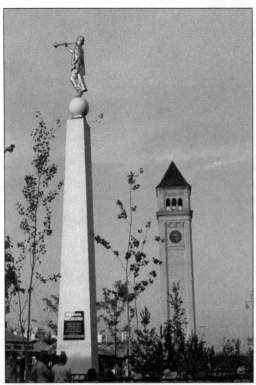

Perched high above the crowds, a gilded figure of the Angel Moroni drew visitors to the Book of Mormon pavilion. When asked how the religious-oriented exhibit fit into Expo's environmental theme, pavilion director Warren Mathwig of the Church of Jesus Christ of Latter-day Saints explained that the exhibit was aimed at "spiritual pollution. And we know there's a lot of this in the nation."

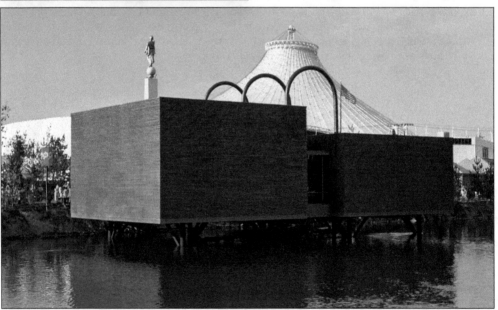

The Book of Mormon pavilion was unusual in that it was built on pilings in the Spokane River. The building was designed to represent the golden plates from which the prophet Joseph Smith translated the Book of Mormon; the plates were shown in book form with large golden rings linking the pages. Inside was *Ancient America Speaks*, a multimedia presentation showing America as described in Mormon teachings. The famed Mormon Tabernacle Choir also appeared for two nights in July.

The 3,600-square-foot pavilion, reached by a 20-foot bridge to the shore, housed two 35-seat theaters. A staff of 24 church elders was on hand to explain the church's mission and to interview prospective new members. On July 23, designated as Pioneer Festival Day at Expo, 2,000 Mormon youth from across the Northwest took place in a series of dance and song performances at the International Amphitheater.

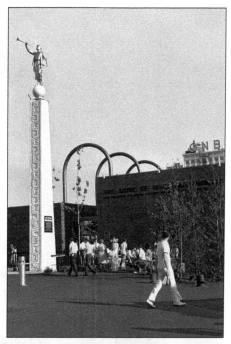

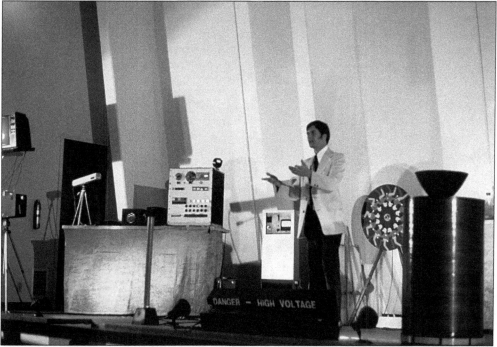

The Sermons from Science pavilion was sponsored by Christians for Expo, a Spokane-based nonprofit religious corporation. A repeat of similar exhibits at the 1962 Seattle, 1964–1965 New York, and 1967 Montréal world's fairs, the pavilion featured 18 different programs each day, including films from the Moody Institute of Science in Los Angeles. In the most thrilling demonstration, Dr. George Speake let one million volts of electricity pass through his body to demonstrate his faith in scientific principles.

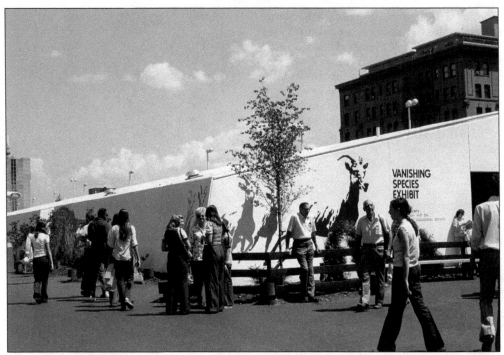

Spokane County sponsored the *Vanishing Species Exhibit*, which warned how mankind had caused many types of animals to become extinct and was in danger of eradicating others. Stuffed extinct birds were used to show that no one would ever be able to see one in flight again. Happily, a section of success stories showed how education and proper management of natural resources had worked to reduce or eliminate this danger for several other species.

The Joy of Living pavilion housed a wide variety of exhibitors that were loosely grouped together with the theme of "Today's Lifestyles." The diverse group included railroads, an airline, a keyboard manufacturer, a heavy machinery company, a kitchen appliance manufacturer, a boat designer, a ski resort, and the US Air Force. In front was one of four Information Centers sponsored by Safeco Insurance.

The $1 million Energy pavilion presented a series of exhibits on the search for new sources of energy, a theme that drew considerable scorn from critics who decried the lack of emphasis on energy conservation instead. Asked to respond, pavilion spokesperson Mary Adams conceded that some of the criticism was valid, but she stressed that the pavilion exhibits were "trying to convey the point that we put ourselves into a pickle because of (the) overuse of energy."

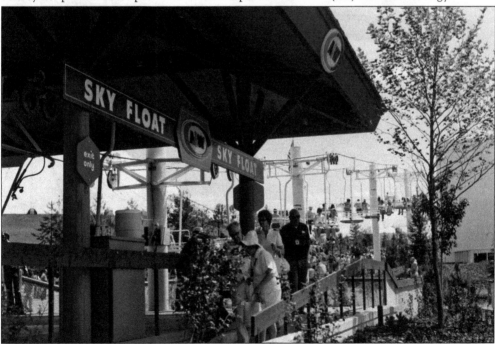

A&W Root Beer sponsored the A&W Sky Float, which was cleverly named to make riders think of a root beer float. One of two aerial rides at Expo, the A&W Sky Float carried riders across the site from the Washington State exhibit to a station near the Iran pavilion and the International Food Fair. The system was built and operated by a now defunct local company, the Riblet Tramway Company, which was once the largest ski chairlift manufacturer in the world.

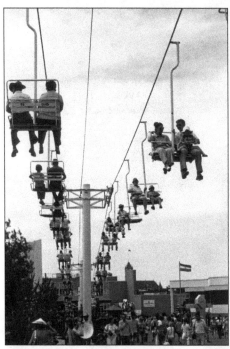

The aerial ride was originally called Sky Safari, and that name appears on postcards issued before the fair opened. When the ride was built, it included small pipes under each of the support stanchions that would have been used for explosive charges to demolish it if the ride was not sold after the end of Expo. Fortunately, the system was sold to the Schweitzer Mountain Resort in Idaho, where it became known as Chair 7.

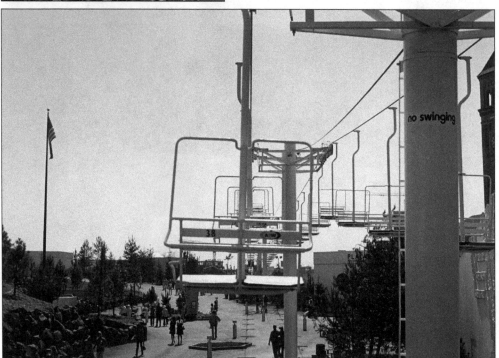

Not long after Expo '74 opened, riders discovered that it was relatively easy to make the A&W Sky Float chairs swing from side to side. The operators soon realized it was also easy to derail the ride, so they placed "No Swinging" signs on the chairs and support poles. The signs may have made a difference, but word that swinging the chairs could get riders ejected from Expo, or even arrested, probably had more of an impact.

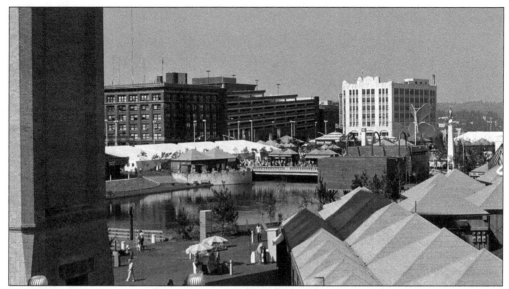

Unlike many world's fairs, there was no lofty observation tower at Expo '74 to enjoy views of the site. The tallest structure, the Great Northern Clock Tower, was not open to visitors, so the A&W Sky Float became popular with photographers trying to capture wider shots of the grounds. The ride was also a hit with folks who wanted to get a brief respite from the crowds below. The ride could carry 2,400 passengers per hour, and ridership more than exceeded the concessionaire's expectations.

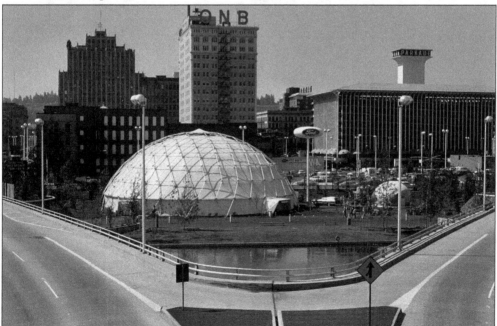

A large net was hung under the route of the A&W Sky Float as it passed over Washington Street to catch falling items before they could hit passing cars. On May 12, 1974, an unidentified teenager fell from the ride in this area, dropping 26 feet and passing right through the net, which was never intended to capture such a heavy load. Luckily, he did not appear to be seriously injured as he fled before the authorities arrived on the scene.

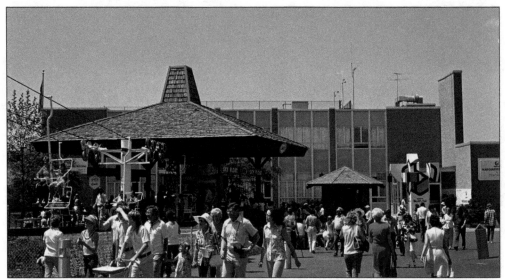

The Havermale Island end of the A&W Sky Float was near the Expo '74 headquarters building. The building looked out of place, being rather utilitarian, but there was a good reason for it. The building had been constructed for the YMCA just before work began on Expo, and the owners fought the fair's initial attempts to condemn and raze it. After a series of legal tussles, it was agreed that Expo would rent it for the duration of the fair then return it to the YMCA.

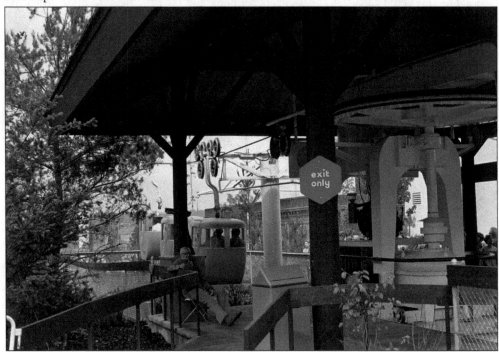

Although Expo '74 was relatively small, it featured another aerial ride. The Skyride, sponsored by Washington Water Power, was also designed and operated by the Riblet Tramway Company. The system carried riders on an exciting trip from the station, which was located between the General Motors and Energy pavilions, out of the fair site and over to Spokane Falls, turning around at the Monroe Street Bridge.

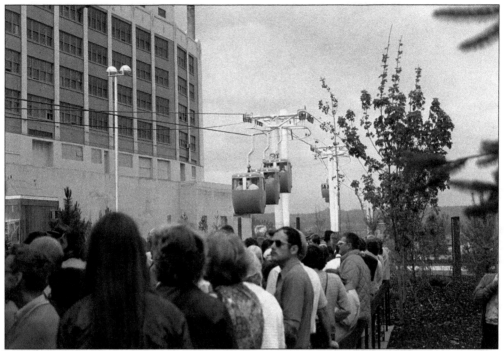

The Skyride was a relatively low-capacity attraction. There were 18 gondolas, which each seated four riders, but the system needed to stop to load and unload each car. To reduce the waiting times, the cars were sent out in groups of three. Even with that, the rated capacity was only 500 riders per hour.

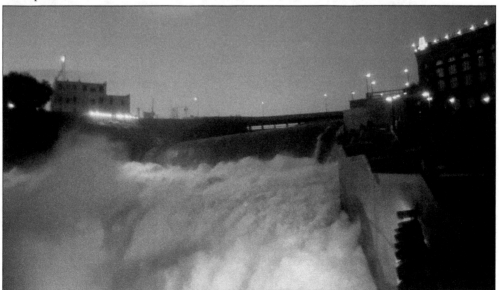

Dipping far down into the river gorge before looping back to the station, the Skyride provided some spectacular views of Spokane Falls. The ride was especially popular in the evenings, since the cabins could be very uncomfortable in the daytime heat. The original system lasted until 2005, when it was replaced with an upgraded version. The new cars are still uncomfortable on hot days, but now the system is shut down in extreme temperatures.

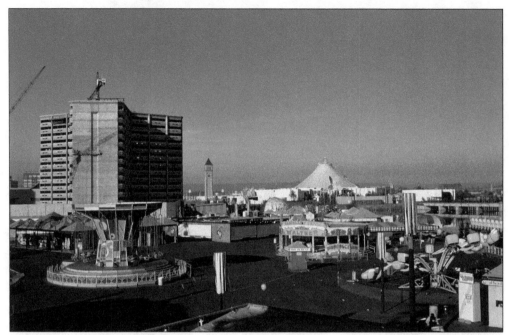

Expo '74 had plenty of other rides besides the two aerial systems. In fact, there was a whole section devoted to them, the Great Northwest Midway, which was located on the eastern side of the site and accessible via the Yellow and Orange Gates. Seen off to the left is the Sheraton Hotel, which was not completed in time for Expo.

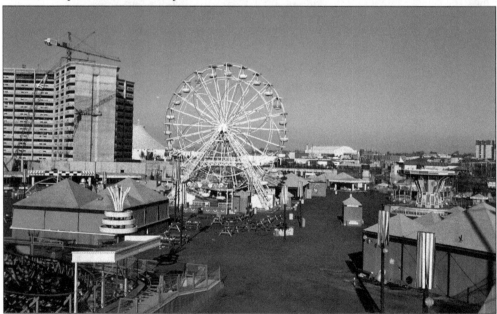

The *Official Guidebook for Expo '74* lists this area as Universa and proudly proclaim it will feature "a 21-ride salute to your spirit of adventure!," with some of the newest and most daring rides in the world. Unfortunately, between the time the guidebook was printed and Expo opened, negotiations with the original concessionaire collapsed, and fair officials had to scramble to come up with a somewhat less ambitious offering, the Great Northwest Midway.

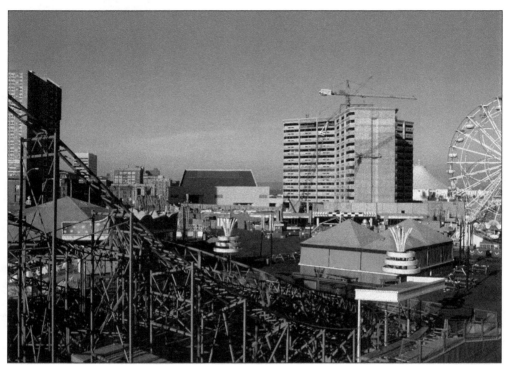

Some of the rides were indeed imported from around the world as originally advertised, including the Jet Star 2, a $500,000 roller coaster from Germany, but, in general, the area looked like the midway of many a state fair, with a Ferris wheel, roller coaster, fun house, and carnival games. After Expo ended, the roller coaster was sold to the Lagoon Amusement Park in Farmington, Utah, and is still in use today.

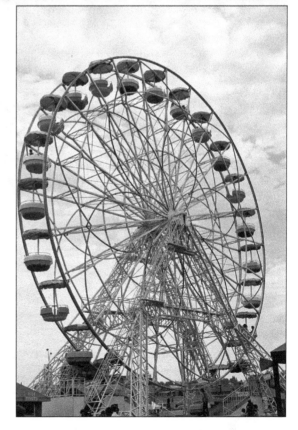

One of the main attractions at the Great Northwest Midway was a $350,000 Ferris wheel imported from Italy. The 85-foot-high ride provided some great views of the fair site, and it also introduced a bit of a thrill with cars that could be rotated a full 360 degrees, turning as fast as the riders could twirl them. Unfortunately, the wheel's brakes did not work when wet, making it hard to stop the ride, so it was closed in inclement weather.

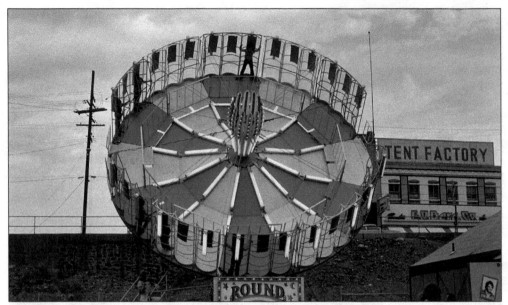

Another popular ride was Round Up, a gravity-defying experience that pinned riders against the outside wall through centrifugal force, then raised them into the air as the platform tilted. Each of the rides in the midway required a ticket; most were 75¢ for adults, 35¢ for children. The midway stayed open until midnight, while the main Expo pavilions closed at 10:00 p.m. A special $1 admission ticket was available to after-hours visitors.

Fair visitors who wanted to find other recreational opportunities or thrills in the Spokane area had plenty of choices at the Travel Terrace. Local vendors offered a wide range of activities that included hot-air balloon rides, white-water rafting, fishing expeditions, horseback rides, helicopter tours, visits to Indian reservations, and more. There were also vendors hawking trips to other destinations across the northwestern states.

The use of low-cost modular buildings made participating in Expo '74 an attractive solution for many companies hoping to gain new business from the attendees. Hughes Airwest was a regional carrier owned by billionaire Howard Hughes. Its planes were painted the same bright colors as its booth, prompting many to say they looked like flying bananas, so the company proclaimed it was "The Top Banana in the West." The company was sold in 1980. (Courtesy of Ellen McFadden.)

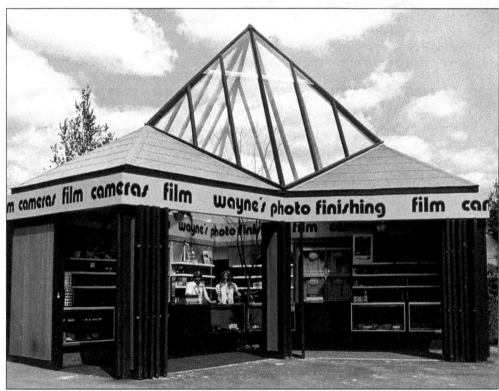

Although Kodak had a pavilion at Expo, the right to sell film on the grounds had been licensed to Wayne's Photo Processing, a Washington-based firm. In the pre-digital photography days, this was likely a lucrative arrangement. Wayne's also sold souvenir slides, cameras, and photographic accessories.

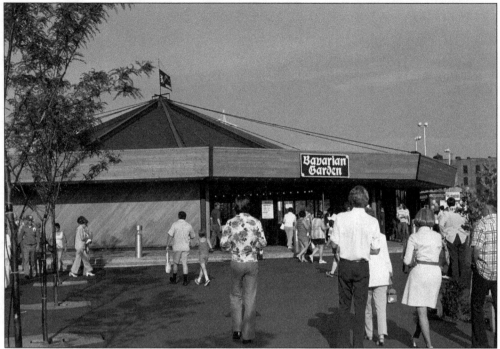

One of Expo's major restaurants was the Bavarian Garden. The building did not look particularly Bavarian and for a good reason. The 10-sided structure, designed with post-Expo use in mind, had a specific requirement to provide a large amount of open floor space. The reason? It would later house a carousel that would be part of the planned permanent park.

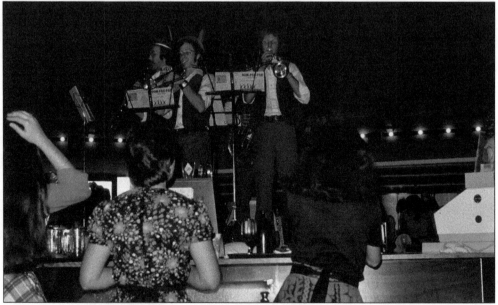

The inside was not at all Bavarian in design, but the entertainers did their best to provide at least a touch of Germany. From the look of their adoring female fans, it would appear they were quite popular. The restaurant attracted large crowds, who were drawn by the music, relatively affordable prices, and, of course, plenty of cold beer.

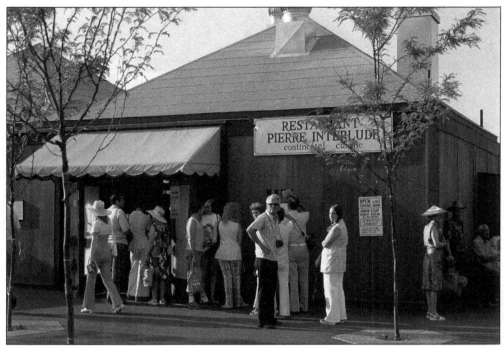

Next door was Restaurant Pierre Interlude, operated by Pierre Parker, who was originally from Tours, France. Parker had previously operated restaurants at the 1962 Seattle, 1964–1965 New York, 1967 Montréal, and 1968 San Antonio world's fairs, and as a resident of Spokane, he was determined to open one at Expo '74 as well. The price for a full French dinner was around $3, plus drinks.

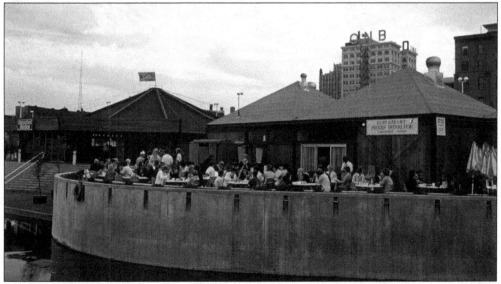

The specialty of the house at the Restaurant Pierre Interlude was "all-you-can-eat" onion soup served with garlic bread. It housed 65 diners inside who were seated on pews salvaged from a local church and another 75 on the patio next to the river. There were often long lines waiting to get in. Pierre Parker would later keep his streak alive by opening another Interlude restaurant at the 1982 World's Fair in Knoxville, Tennessee.

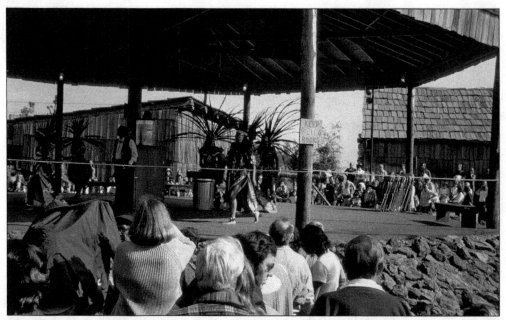

The Folklife Festival area, located on the north bank of the Spokane River, featured a wide variety of activities. Many dance troupes and musical groups performed there, as well as other shows as varied as logging competitions, totem pole carving, and even smoking salmon over alder fires. Visitors could try their hand at panning for gold; it was very popular, but there are no reports of anyone getting rich.

In addition to all of the entertainment inside the pavilions, there was a great deal to see scattered throughout the grounds. The Expo '74 organizers knew the importance of keeping people entertained as they waited in lines and in making the area seem vibrant and exciting, so they included an ambitious street performance aspect. Some acts were hired for the entire Expo season, while others performed there as they passed through the Spokane area.

Many of the performances looked quite impromptu, seemingly set up at random between the pavilions, but their schedules were carefully coordinated to spread the acts across the site and to stagger them throughout the day. This group of Dixieland musicians looks quite chilly; as seen from the lack of leaves on the trees, it was near the end of Expo and the weather was indeed quite brisk at times.

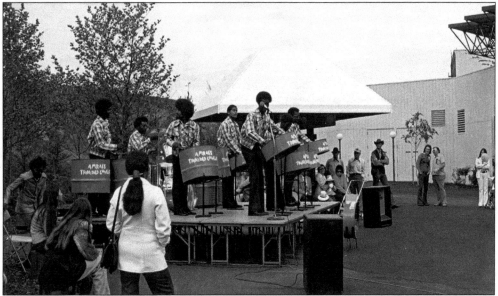

There were also a number of small entertainment venues across the site. Some were temporary stages, such as this one used for a steel drum band performance. Amral's Trinidad Cavaliers Steel Band, based in Trinidad and Tobago, stopped by Expo '74 as part of a world tour, performing there for the run of the fair. In addition to the paid performers, there were many appearances by visiting schools and civic organizations.

One of the most unusual of the performers was Evelyn Roth, who recycled unexpected materials into a wide range of products. She is seen here weaving used two-inch-wide industrial videotape into a large sun shade that was later hung over a seating area on Canada Island. More than one mile of the tape was used to create the 1,500-square-foot canopy. Even her hat was made from recycled videotape.

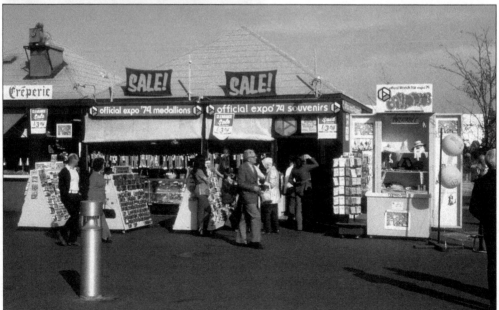

As wonderful as it was, Expo '74 finally came to an end. Seen here on October 29, guests still had nine days left to bring some souvenirs home, and at bargain prices. More than 900 different souvenir items were produced for sale at 12 stands across the grounds and in the pavilions, an amazing number of items for such a small fair. It is hard to visit an antique store in the Northwest today without spotting one.

Four

RIVERFRONT PARK TODAY

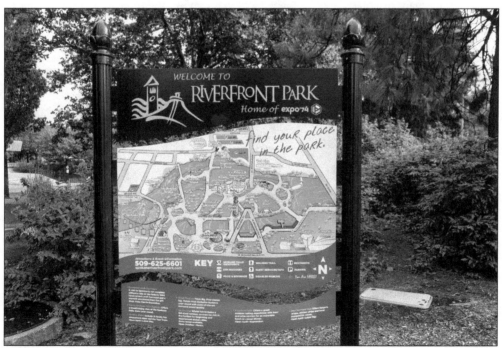

Some world's fairs leave little to mark their passing. For example, it is next to impossible to find signs that New Orleans hosted a fair in 1984, and the few remnants of Vancouver's Expo '86 are in peril. Fortunately, the site of Expo '74 was designed from the start to be used as a public park, and today, Riverfront Park is one of the most vibrant of all the former fair locations. Returning Expo fans will be thrilled to find many remnants of the fair still there.

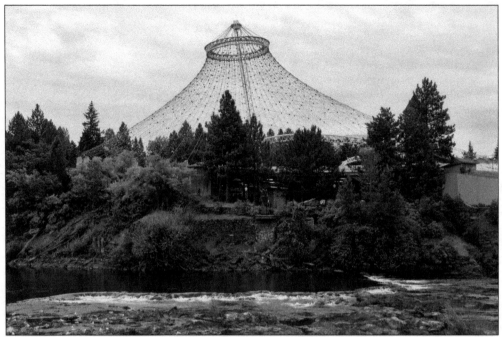

The original plans for the park called for the removal of the tent over the United States pavilion because it was made of a material not designed for long-term use and there were no provisions to deal with snow accumulation. The popularity of the iconic structure led to its being left in place, but the vinyl cover was removed several years later when it began to deteriorate and pieces fell off. Sections of the roof were mounted on plaques and sold as souvenirs.

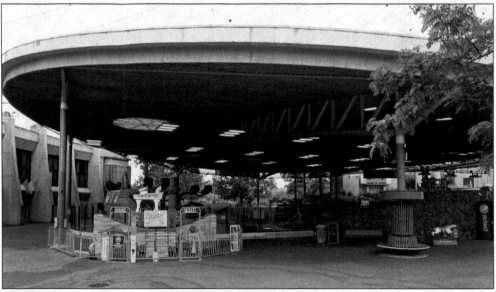

The center of the former pavilion is now used for a variety of purposes, with a new roof added to provide protection from the elements. During the spring and summer, it houses a number of children's rides, including a roller coaster, bumper cars, and a boat ride, with a Ferris wheel just outside. In winter months, the area is used for ice-skating. The former Environmental Action Center is now an arcade.

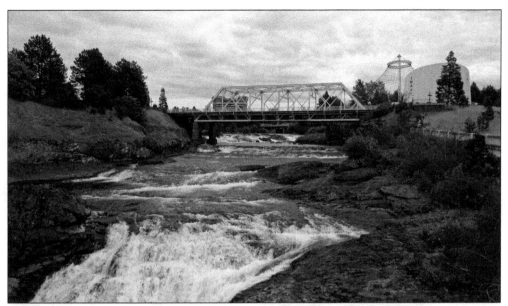

The original IMAX theater inside the United States pavilion was abandoned when Expo closed, but a new one is now part of Riverfront Park and is seen at right. The Howard Street Mid-Channel Bridge no longer sports its colorful Expo cloth panels and is scheduled to be replaced with a more pedestrian-friendly design. Just as planned, the Spokane River attracts thousands of visitors to the park each year.

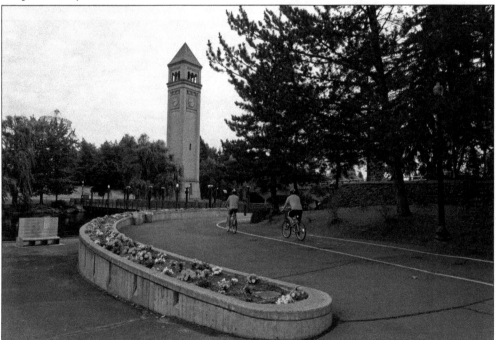

Some of the walkways that crisscrossed Expo '74 have been removed over the years, but others now provide a leisurely way for pedestrians and cyclists to tour the park as the wide designs used for Expo lent themselves well to providing bike lanes. New flower beds and sculptures added since 1974 help make the park a lively and vibrant part of Spokane life.

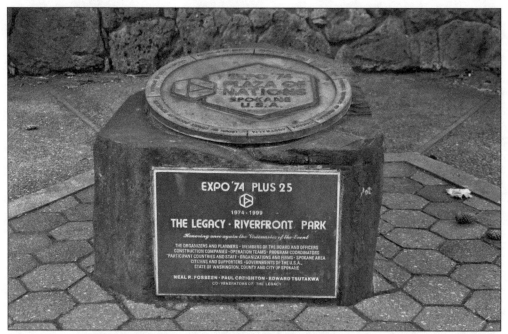

Some cities all but ignore their world's fair heritages, but Spokane continues to celebrate the six months of Expo '74 and the positive impact it had not only on the park, but also on Greater Spokane. The 25th anniversary of Expo was honored with a number of celebrations, including the addition of a new plaque under the one originally installed at the Plaza of Nations.

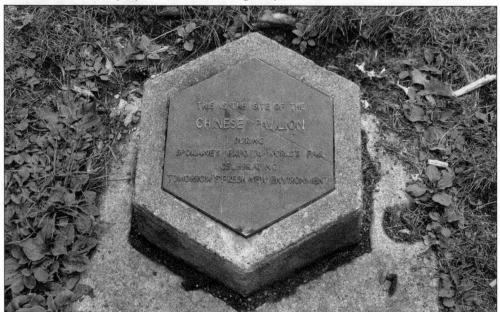

There are also a number of smaller markers denoting where some of the pavilions once stood. Not all of the sites are identified in this manner, but the park contains ample signage with historical data on the Expo days. Overall, it is quite easy for visitors to orient themselves and trace back to where the world's fair structures were, making it a pleasant experience for those who enjoyed Expo '74 so much.

One of the most beloved relics of Expo '74 can be found near the carousel building. Created by Sister Paula Mary Turnbull of the Convent of the Holy Names in Spokane, the goat is actually a pneumatic trash receptacle. Children and adults alike enjoy waking up the Garbage Goat by pushing the button on the wall, then watching as it sucks up trash held under its mouth. This area is always one of the cleanest in the park!

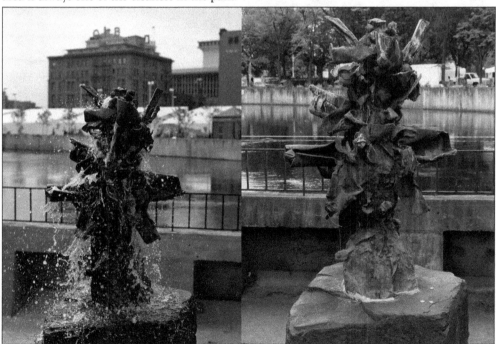

Not all of the items left from Expo '74 are in as good condition as the goat. Seen here is the sculpture *Totem No. 2* by Nancy Genn. During its Expo days, it included a gushing fountain, as seen on the left, but the water element was removed years ago. Riverfront Park also features several artworks installed since Expo, further adding interest to the site.

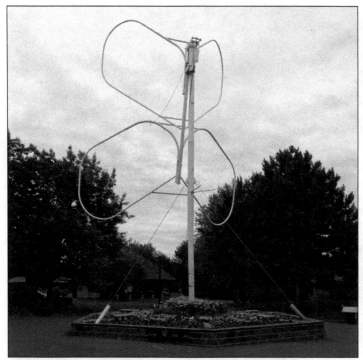

Five of these large butterfly figures once marked the gates to Expo '74, but today only one remains. This one stands at the former Lilac Gate area, sadly without its colorful cloth panels. The city had planned to remove it in 2008, but an unexpected show of support from community volunteers helped save it. Parts from another surviving butterfly now in storage are used to maintain this one.

The Skyride still offers exciting rides above Spokane Falls. The original system was replaced with an updated version in 2005, including new cars, but they still travel in groups of three just as they did during Expo '74. The new cars share one unfortunate trait with the old version; they become extremely hot on warm days, so the ride is generally shut down when the outside temperature reaches 90 degrees.

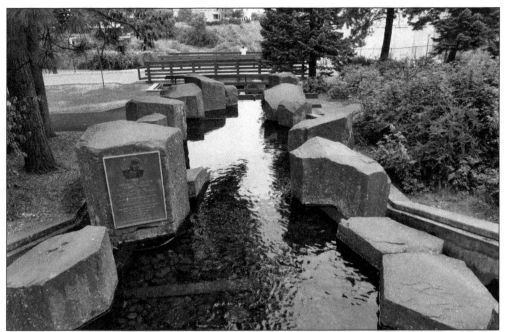

The Theme Stream still flows and is a popular resting place for those walking in the park. A plaque was added in 1988 to honor the man who pushed the project through to completion, Thomas S. Adkison, the executive architect for Expo '74. The trees around it have grown up since Expo, making the man-made stream seem a bit more natural.

The Spokane Opera House portion of the former Washington State pavilion is now known as the INB Performing Arts Center and is sponsored by Inland Northwest Bank. Just next door is the Spokane Convention Center, which was created by expanding the exhibit hall section of the pavilion. The entertainment complex is an important part of Spokane's cultural scene and was last expanded in 2015.

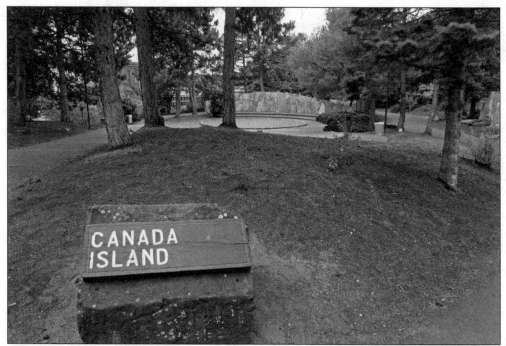

Canada Island is the most undeveloped portion of the park. Heavily wooded, the area is a serene respite from the busy streets of Spokane. The suspension bridges linking the island to the mainland are still popular spots to cool off on hot days. The former Alberta amphitheater can be seen here in the background. In 2016, it was announced that the island would be renamed to honor indigenous tribes of the area.

Portions of the former British Columbia pavilion still stand but are currently unused. The building originally had three hexagonal sections, but one has been demolished, leaving only a concrete footprint to mark where it stood. The remaining sections of the building are in good condition, but there are no current plans to make use of them.

The former Bavarian Garden restaurant now houses the historic 1909 Looff Carousel, which was formerly part of Natatorium Park, an amusement park that closed in 1968. The closure of that park was one of the key driving forces behind Expo '74. Desperate to find a home for the beloved ride, city leaders launched the revitalization of the downtown area by holding the world's fair, knowing the carousel would be part of the park that was to follow.

In 2014, following several years of neglect and deterioration of the park's facilities, voters approved a bond measure to fund ongoing improvements to Riverfront Park. Some of the Expo '74 relics will be replaced, such as the old carousel building, and new and expanded facilities will take their place during a four-year project launched in 2016. The legacy of Expo '74 seems assured for future generations.

Visit us at
arcadiapublishing.com